# photographing your children

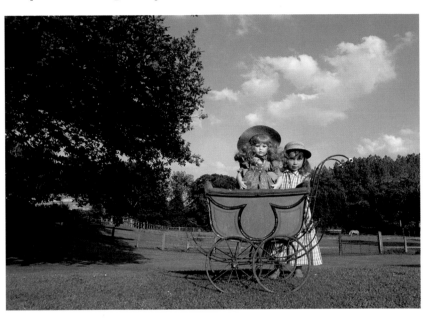

# photographing

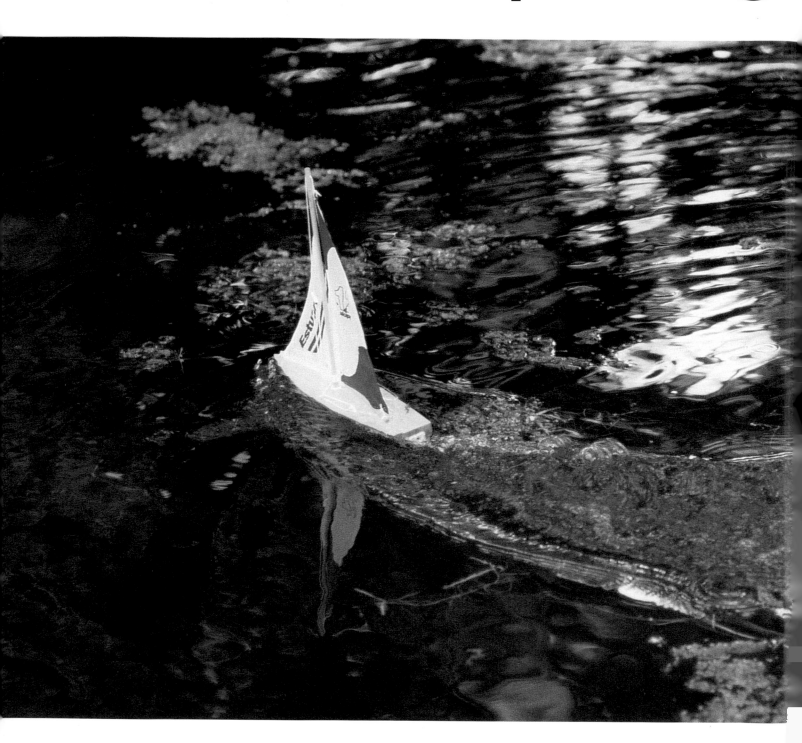

# your children

## John Hedgecoe

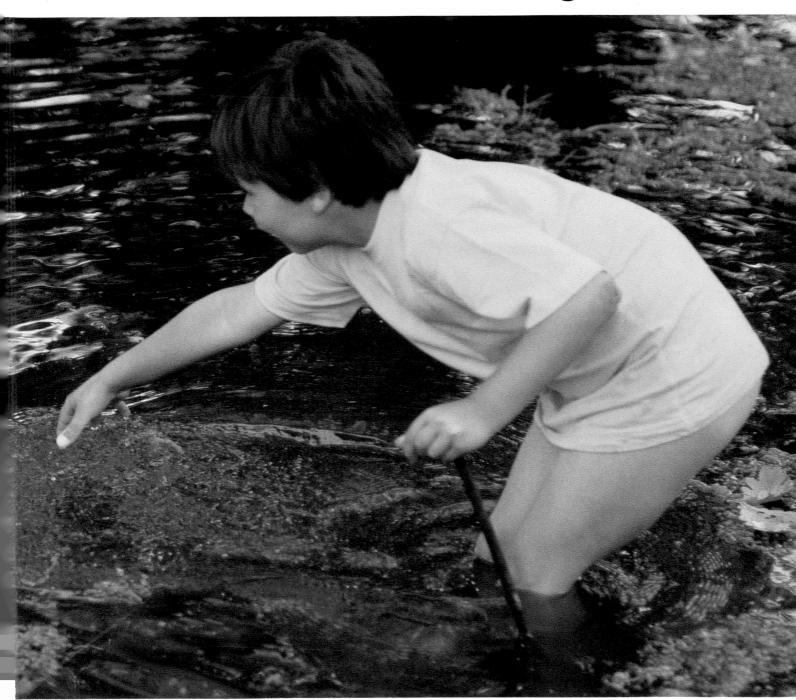

COLLINS & BROWN

## Acknowledgments

The author would like to thank Chris George and Jenny Mackintosh for their help in compiling the book.

He would also like to thank Barbara Sutton's School of Dance; Melrose Farm Stables, Guernsey; Manor Riding Stables, Guernsey; Robert and Stephanie Neath; the Carter family; the Elsden family; Colorama Photodisplay Limited; Pegasus Pushchairs Limited; and Olympus (UK) Limited for the photograph on page 106.

First published in Great Britain in 2000 by
Collins & Brown Limited
London House
Great Eastern Wharf
Parkgate Road
London SW11 4NQ

Distributed in the United States and Canada by
Sterling Publishing Co.
387 Park Avenue South,
New York, NY 10016 USA

1 3 5 7 9 8 6 4 2

British Library Cataloguing-in-Publication Data:
A catalogue record for this book
is available from the British Library.

ISBN 1 85585 809 6

Editorial Director: Sarah Hoggett
Contributing Editor: Chris George
Designer: Roger Daniels

Reproduction by Global Colour Ltd, Malaysia
Printed and bound in Hong Kong by Dai Nippon Printing Co.

# contents

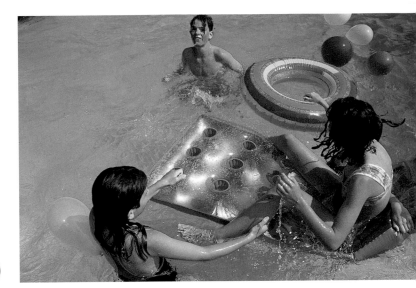
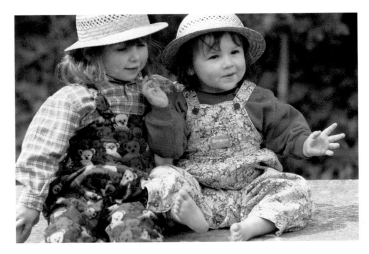
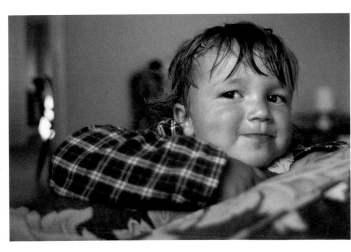

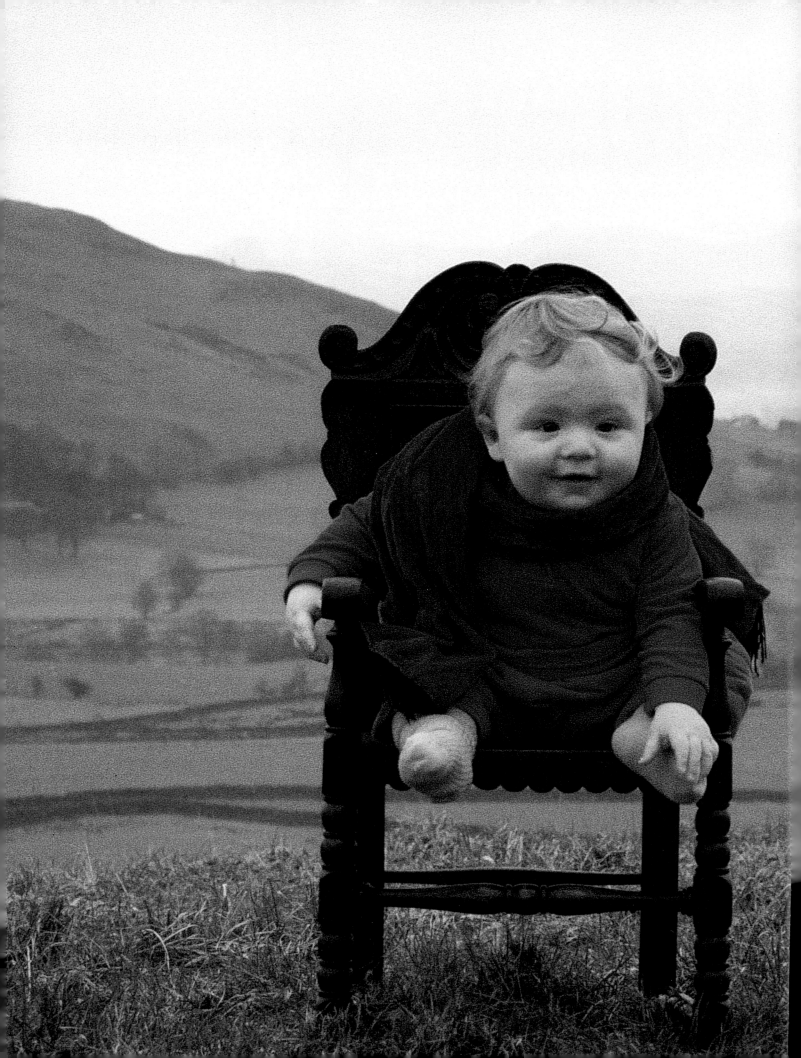

# introduction

For many people, the arrival of children in the family is the catalyst that provokes them into taking photography more seriously. Whether it is your own child, a grandchild, a niece or nephew, the birth of a baby is almost certainly guaranteed to start family and close friends clambering to load and point their cameras.

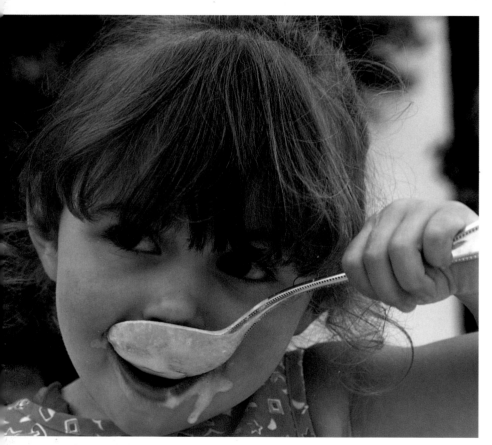

△ **Candid camera**

It may be a cliched idea that children make a mess when they are eating, but such candid shots are almost guaranteed to produce great results.

But whilst it is easy to remember to use your camera at the beginning of a baby's life, it is much harder to keep a truly representative record of a child's early years.

When my first child was born, I set out with the intention of taking a picture of him every day for the first year. But even for a professional photographer, this was an idea that soon fell by the wayside.

Every other parent will tell you that children grow up very fast, but it is only when you have your own that you understand what they mean. Babies pass through each developmental stage so quickly – learning to smile, crawl, eat, make noises, and many other skills during the first few months alone. It is all too easy to find that your photographs of your children do little more than mark the birthdays and holidays. One day you realize that your baby is now a toddler, and that you never captured on film those first tentative steps he or she took on the way to learning to walk, missing such milestones forever.

To avoid such gaps, it is worth making photography part of your weekly routine, just as you would make going to the clinic. If you could shoot just one good picture every week, you would have an album of 50 photographs charting your child's development over the first year, and would not miss any major stage.

Charting your baby's progress from tot to teenager is far more than a creating a scientific record, however, and it might seem unnecessary to turn the photography of your children into a task that must not be forgotten.

However, the arrival of a child in the household is liable to change the lives of its parents substantially. In the first

▷ **Formal poses**

It is worth trying a more formal approach with your pictures, as if you were in a proper studio. With a plain wall as a backdrop, this girl was quite willing to pose in her dressing-up clothes. Imagine what a great present a shot like this would make for the grandparents.

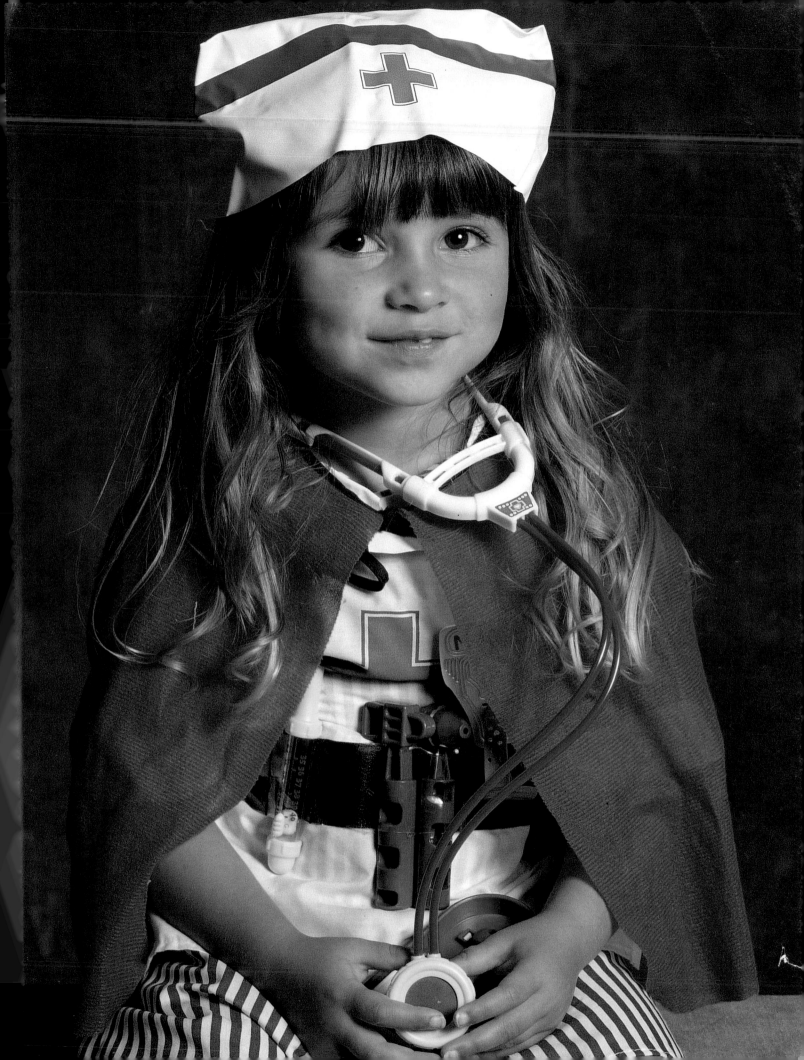

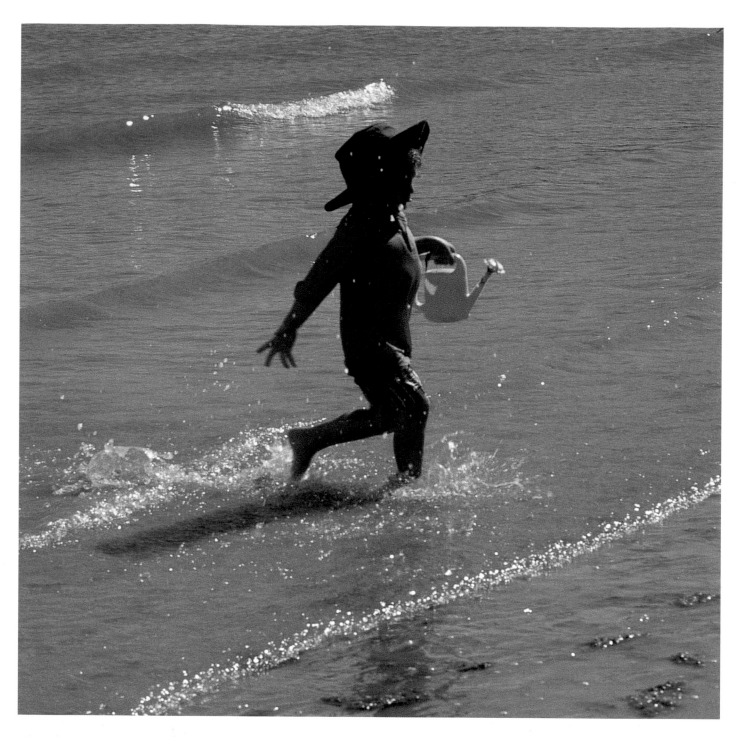

△ **Holiday fun**

Beaches and other open spaces allow kids a freedom of movement and activity that they are not allowed at home. This provides great photo opportunities – just let the lens follow what they are doing, and click when you have an interesting shot in the frame.

couple of years, in particular, it may seem that you do little more than look after the child. Remember, though, that it is the everyday things in a child's life that are often the most important to commit to film – it doesn't matter if your shots are not dramatic or perfectly composed at this point, as long as you capture his or her spirit and personality.

Of course, any parent is going to want more than mere record shots to look back on in years to come. And this is also where this book is designed to help. Children are not the most difficult of photographic subjects – in fact, it can be surprisingly easy to get satisfying results even with the most modest equipment. However, there are a number of things

to watch out for if you want to achieve good shots.

Dealing with children as photographic subjects is very different from trying to take pictures of adults. Children are often willing subjects, adopting poses, props and clothes to suit your wishes. But children rarely react well to being cajoled into performing in front of the camera, and have a surprisingly short attention span.

If you don't want your children to grow up dreading the sight of your camera, I believe that photography sessions should always be fun – for all concerned. Make sure that the children get involved with the sessions as soon as they are old enough, letting them suggest ideas for the pictures.

Don't allow each photographic session to last more than a couple of minutes. If it goes on longer than this, you not only risk alienating your subjects, but the spontaneity of their expression begins to fade. Should your child prove uncooperative on a particular occasion, put the camera away. It is far better to wait half an hour, until the child's mood has changed, rather than forcing them to pose unwillingly.

Whilst you can prepare for some pictures, it is always worth having your camera loaded and ready to fire – when there are children around, you can never be certain what will happen next!

### ▷ Show-off

This little girl was desperate to pose for the camera. Be guided by what children want to do in front of the camera, as this will often produce more natural results than if you choose the pose for them.

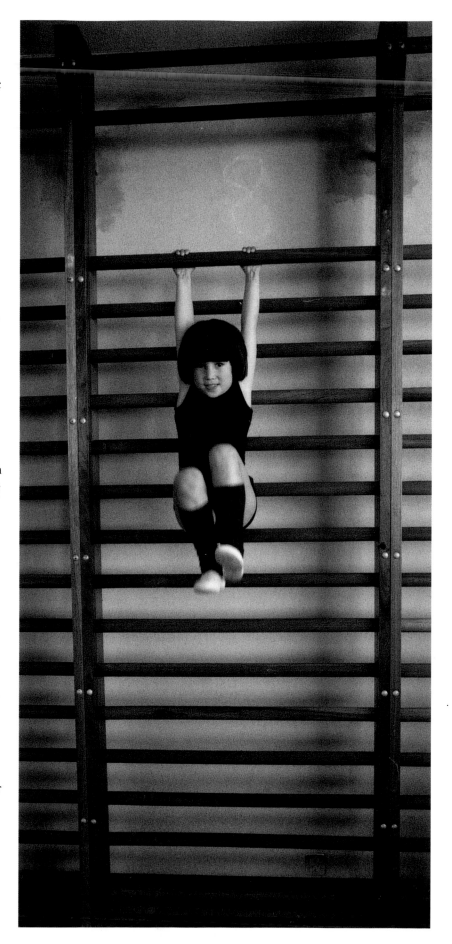

# simple ways to take better pictures

# think about the picture shape

There are always at least two different ways to frame up your pictures: horizontally, or, by turning your camera on its side, vertically. Both can work well with portraits.

▷ **Body contortions**

Rather than standing up, this girl insisted on bending double. The pose suits a square picture frame ideally , so it didn't matter which way I held the camera. The finished print was then cut to the right dimensions.

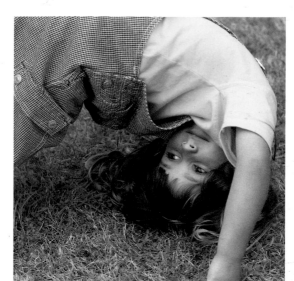

One of the many ways in which you can affect the appearance of your picture is by the way you hold your camera. Hold it horizontally for a 'landscape' shot: this format is good for portraits where you want to include lots of the background or for group pictures. But turn it upright for the 'portrait' format which often provides you with a tighter composition, as the upright picture shape closely matches that of the child.

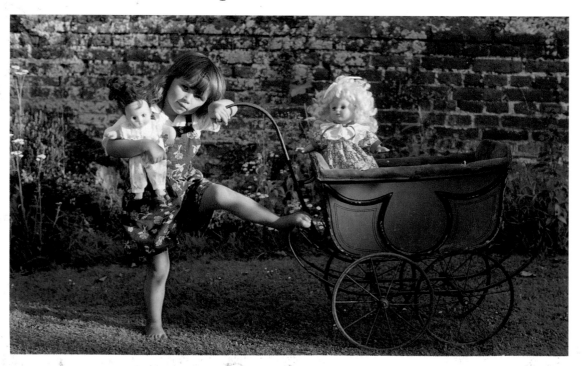

◁ **Landscape format**

The picture of the girl and her pram fits much more neatly into the viewfinder when the camera is held horizontally.

▷ **Portrait format**

This shot was unplanned – the bin was meant to be used as something for the girl to stand on, but her brother had other ideas! Here, holding the camera upright provides a strong composition, with the girl, the bin and colourful hat filling the vertical frame.

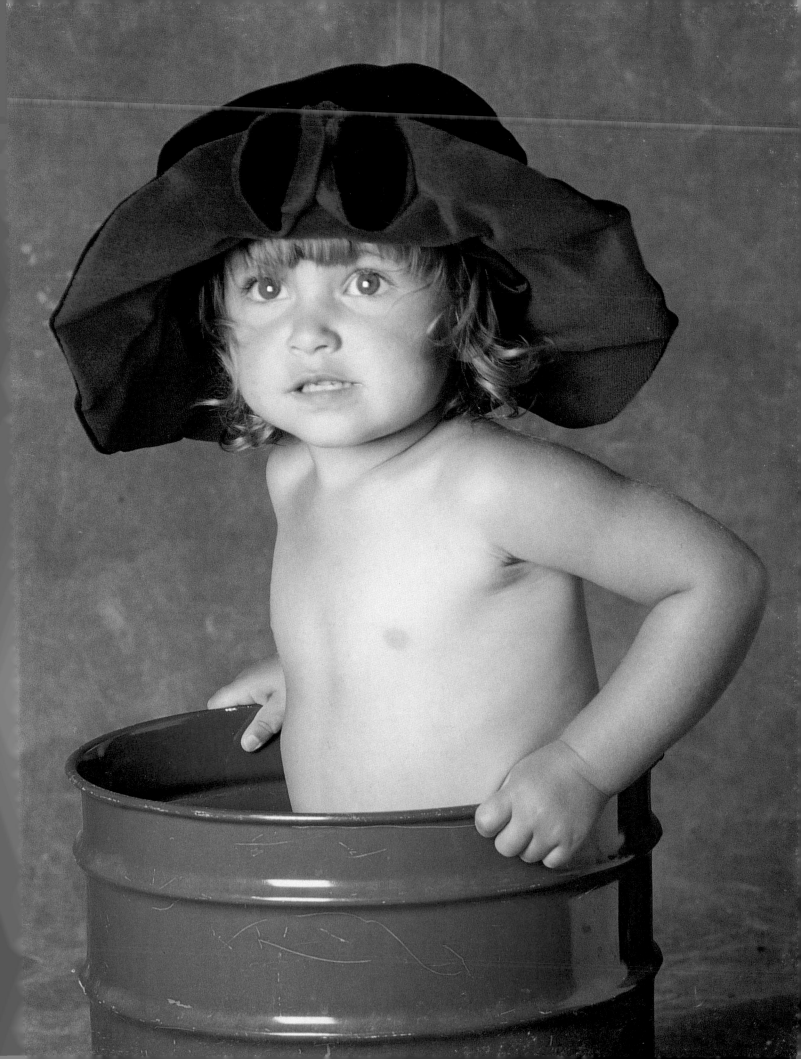

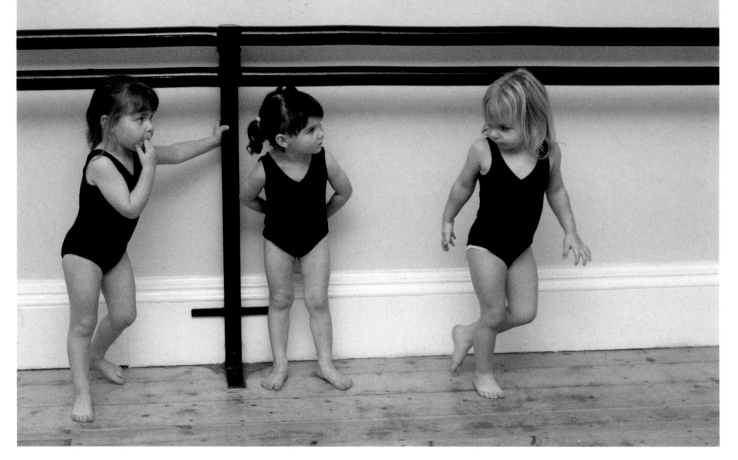

# choose your viewpoint

If you want natural-looking pictures of children, you will have to get your camera down to their level. In short, you will need to get down on your knees – or even lower!

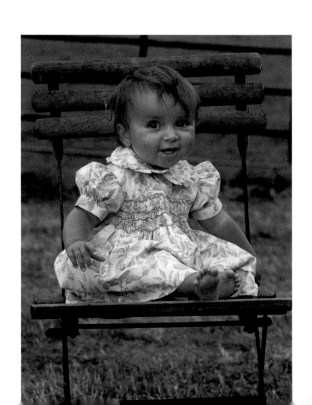

### ▷ Raising the subject

In this shot the small girl was sat on a garden chair, raising her face to a level where I only needed to kneel down to ensure that the camera was at her height. With this sort of shot it is important that a parent is positioned just out of shot, to save the child from falling should they start to topple.

## Useful tips…

• Lie down on the ground to take pictures of crawling babies.

• Sit on a chair backwards so as to be at the level of young school children, then use the backrest as a prop for your camera.

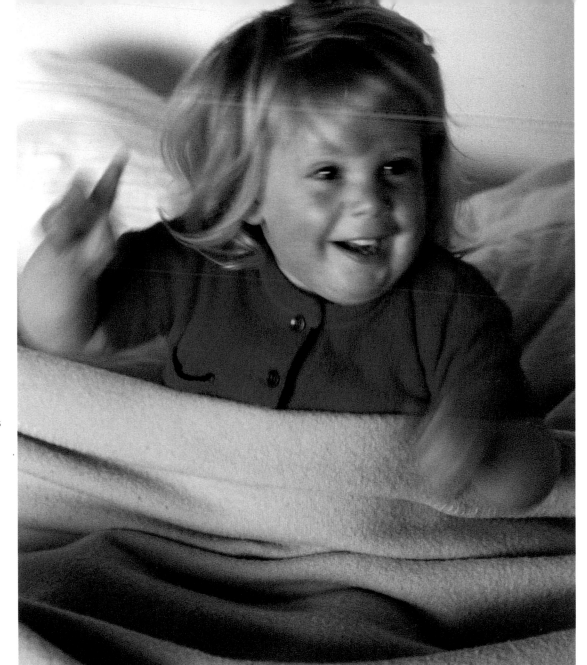

◁ **The best seat in the house**

In the middle of a dance lesson, it was impossible to kneel down in the centre of the room. To ensure that my camera position was not too elevated, I settled to taking pictures of the girls while sitting in a chair at the side of the hall.

The height at which you hold your camera when taking pictures of children can have a dramatic effect on the results. If you shoot pictures with the camera at your own eye level, the camera will tend to look down on the child – literally and metaphorically – exaggerating their diminutive size.

For a more natural view, you need to get the camera down to the child's height. Ideally, the lens should be level with the eyes of your subject. With most children, therefore, you should crouch or kneel down. With babies lying on the floor, or children sitting on the carpet playing a game, you may even find it beneficial to lie on the ground in front of your subjects.

If you want to make children look more powerful and grown-up, a good trick to use is to get the camera level below their heads, so that the lens is forced to look up at them. This can be a powerful way, for instance, in which to show a child sitting astride a bike, so they appear in the shot to rule the roost.

△ **Crouched down**

By stooping down to shoot this picture of a boy in bed, I have ended up with a more intimate, friendly shot than if I had stood tall and pointed my lens downward.

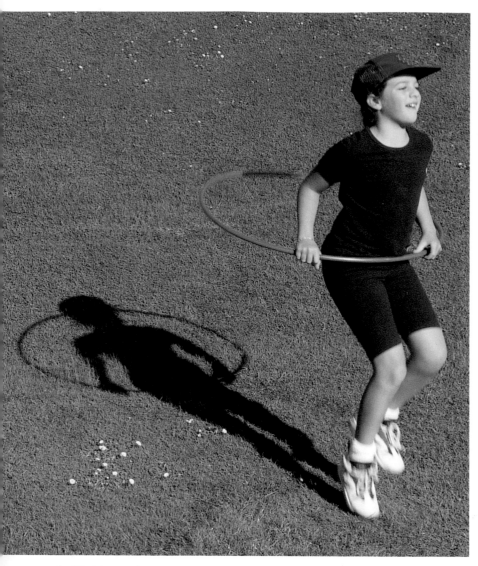

Sunny days do not guarantee brilliant pictures – it is the direction and quality of light which are more important than the brightness of the sun.

△ **Shadowy shapes**

Harsh, direct sunlight of a summer's day has created strong shadows. However, thanks to the plain background, the shadow on the ground adds emphasis to the picture, isolating the interesting shape of the girl and her hoop.

# check where the sun is

When photographing outdoors, the sun can be can be shining directly on the subject or its rays can be obscured by clouds, it can be high in the sky or dipping over the horizon, and the light can be coming from any direction. Whilst it is possible to take pictures in all these lighting conditions, the truth is that some will be easier to get good results with than others.

Photographers used to be told to stand with the sun behind them, and this is certainly the way in which to get the richest colours in your pictures. To improve on this lighting, it is worth standing so the sun is over your shoulders, with the lighting at a 45° angle above and around from the camera. This ensures that there are some shadows in the picture, which are important to help show the texture of the skin and clothes, and to ensure that people appear as a three-dimensional form, rather than a cardboard cut-out.

Direct sunlight, however, can create unsightly shadows under the eyes and nose of your subject, and a much kinder light for outdoor photography comes

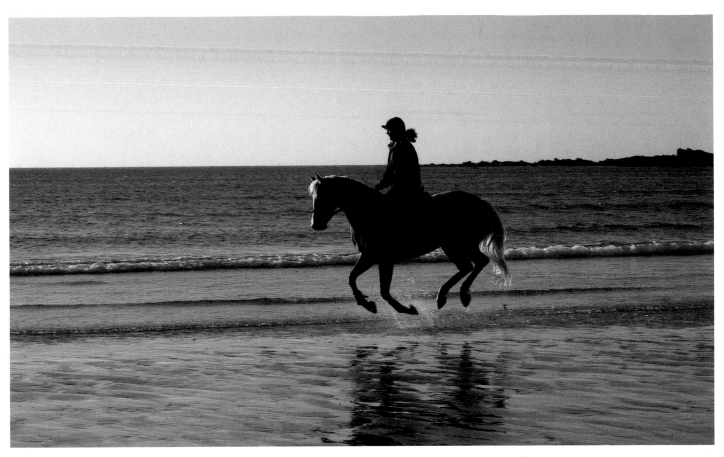

△ **Rim lighting**

Essentially this is a backlit shot, where the shape of the horse and rider have been emphasized by the fact that the sun is in front of the camera. However, the hairs on the horse's head and tail have been caught by the sun, creating a halo-like effect which is known as rim lighting. The technique works best when the sun is just out of the frame, and the background is dark.

when the sun is veiled in a thin layer of cloud. This 'softens' the light, making the shadows less intense and thus producing more flattering close-ups of the human face.

The harshest light to deal with is when the sun is directly behind the subject, and high in the sky. The intense contrast created by such a scene means that it is difficult to achieve anything but a black silhouette, with the subject bathed in shadow. But even this can produce a telling picture, if the shape of the subject is readily identifiable.

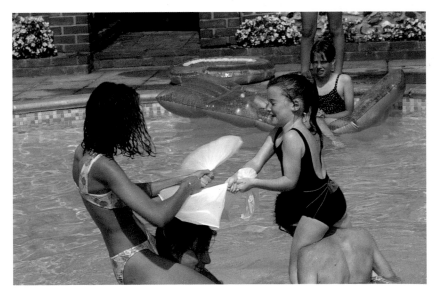

△ **Brilliant colours**

With the light almost directly behind me, the colours in this action shot have been intensified, creating a bright image of the poolside antics. The fact that the faces are bathed in strong shadows is immaterial.

### Useful tips...

• To find soft, diffuse light on the sunniest of days, shoot subjects in shadow areas – reflected light ensures even lighting in these darker areas.

• To minimize exposure problems, use diffuse light or ensure that the sun is behind you.

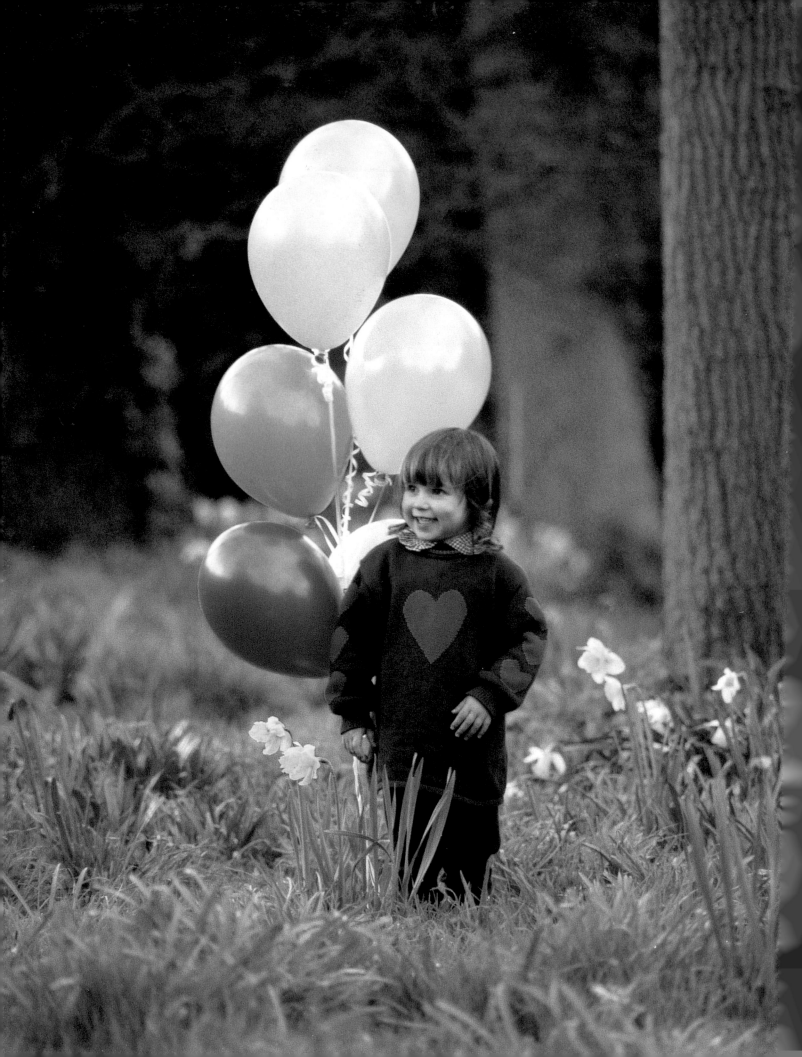

Don't make your pictures too cluttered or complicated – if the background or surroundings don't add anything to your composition, you should leave them out. Find a camera angle that gives you a plainer backdrop.

# keep it simple

△ **Head in the sand**

I deliberately took this picture from my eye level, so that the elevated camera position ensured the sandy beach became the backdrop for the shot.

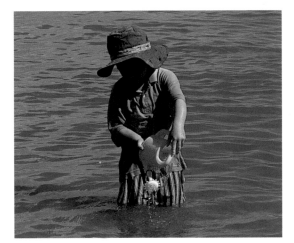

◁ **Choosing an angle**

To avoid including other swimmers in this seaside shot, I had to choose the camera angle with care.

◁ **In a blur**

The greenery of the countryside makes a pleasant backdrop to this birthday girl with her balloons. However, to avoid the trees appearing too sharply behind the main subject, I used a 200mm telephoto lens and a large aperture. This blurred the background just enough so that it did not become a distraction.

It is easy not to notice things when you are looking at a scene through the viewfinder of your camera. You see the child, but you ignore what is going on in the background. When you get the pictures developed, however, you see only too clearly the clutter and mess that surrounds your subject.

To avoid such distractions in your pictures, you need to train your eye to scan every part of the frame before you press the shutter. If the background or surroundings are unnecessarily fussy or detailed, they will detract from your portrait. Furthermore, eliminating these

unwanted intrusions is often extremely straightforward. Moving your camera higher or lower, or around the child slightly, you will often find a plain patch of wall, sky or grass against which you can frame your picture.

With some cameras it is possible to eradicate distracting backgrounds without even having to move position. By selecting a wider aperture or choosing a longer lens setting, it is possible to throw the background so far out of focus that even the most complex background becomes a blurred, unidentifiable wash of colour.

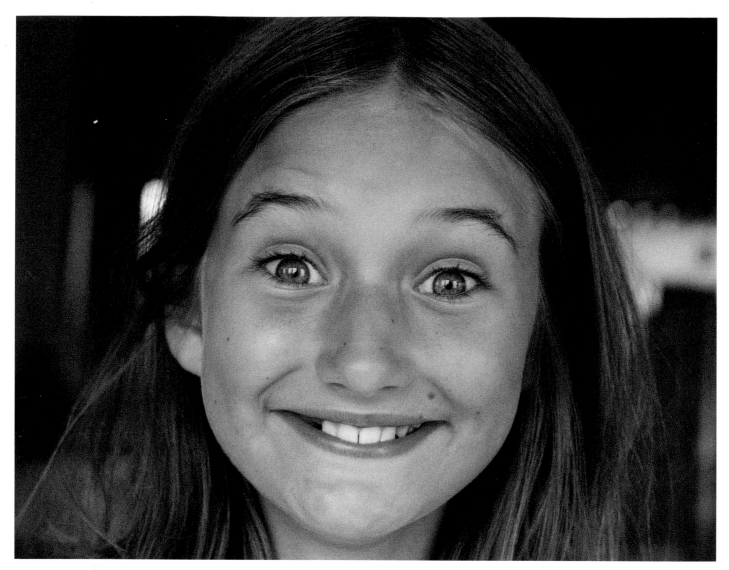

# fill the frame

Increase the impact of your shots by getting in as close as you can, or use a zoom lens to make sure that none of the picture area is being wasted.

The most straightforward way to simplify your images is to get closer to your subject so that they fill the viewfinder. Sometimes you will want to include the surroundings or details of what they are doing, but for a shot with maximum impact, get in so close that the child's head fills the picture.

Don't get so close that the camera cannot focus, though, and if you have a zoom lens, use this to crop unnecessary details from the scene.

△ **Big smile**

I was enthralled by the facial expressions of this girl. Sitting opposite her in a busy restaurant, I was able to use a zoom to ensure that her face filled the frame, excluding the hustle and bustle behind.

▷ **Musical study**

I didn't want the impact of this shot of a piper, dressed in his typical Peruvian clothes, to be diminished by the surrounding tourists. By using the upright format, and getting in close, I was able to exclude the visual distractions.

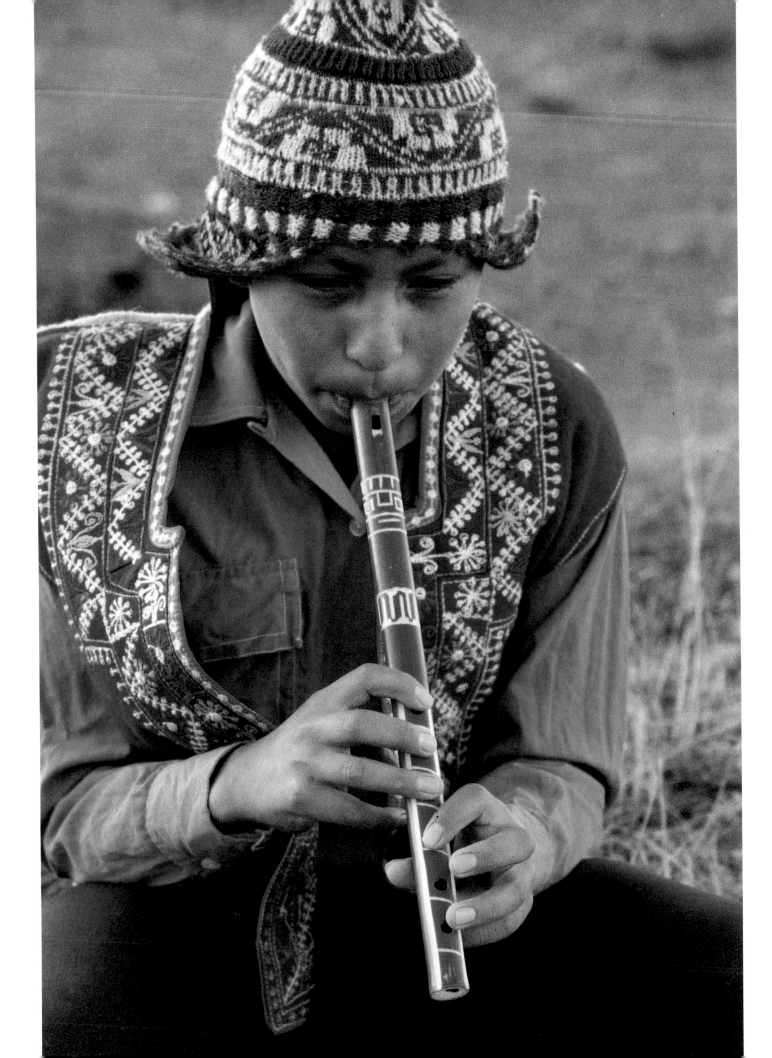

▷ **Figures on ice**

The dozens of skaters on the outdoor rink create a complex scene. But with the subdued lighting and ice-white backdrop, the individual skaters have become little more than shapes. Their poses, however, clearly show what is going on.

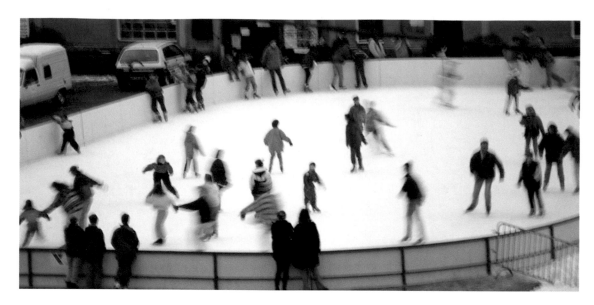

You don't need colour and detail in order to identify a person in a picture, or to tell what they are doing. Sometimes, just the outline will do.

# shape

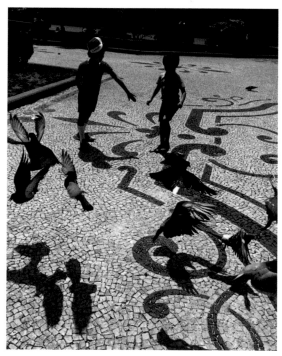

◁ **Catch the pigeon**

With strong backlight, these two boys' faces are obscured by shadow; nevertheless, the outlines of their bodies still convey the fun that they are having as they run around the town square, chasing the pigeons.

You don't always need to see the faces of your subjects clearly in your pictures. In fact, by deliberately obscuring the identity of your sitter, you make the picture more interesting.

A silhouette only shows you the most basic information about a person. There are no shadows, no depth and no detail – just the stark outline. But if you saw such a picture of your child – or of a well-known celebrity, to give an obvious

alternative – you would probably still recognize them.

The simplest way to accentuate the shape of your subject is to shoot against a light background and then expose for this background, so the subject becomes dark. If you use backlighting, you get a pure silhouette. With sidelighting or with diffuse light, the effect is more subtle: colour, texture and form are suppressed, not completely eliminated.

▷ **Hanging on**

The shape alone is often all that you need to convey the spirit and feeling of the person, and the activity that they are involved in. The young gymnast appears almost as a silhouette against the white wall, but her sense of fun and adventure are still obvious from the shot

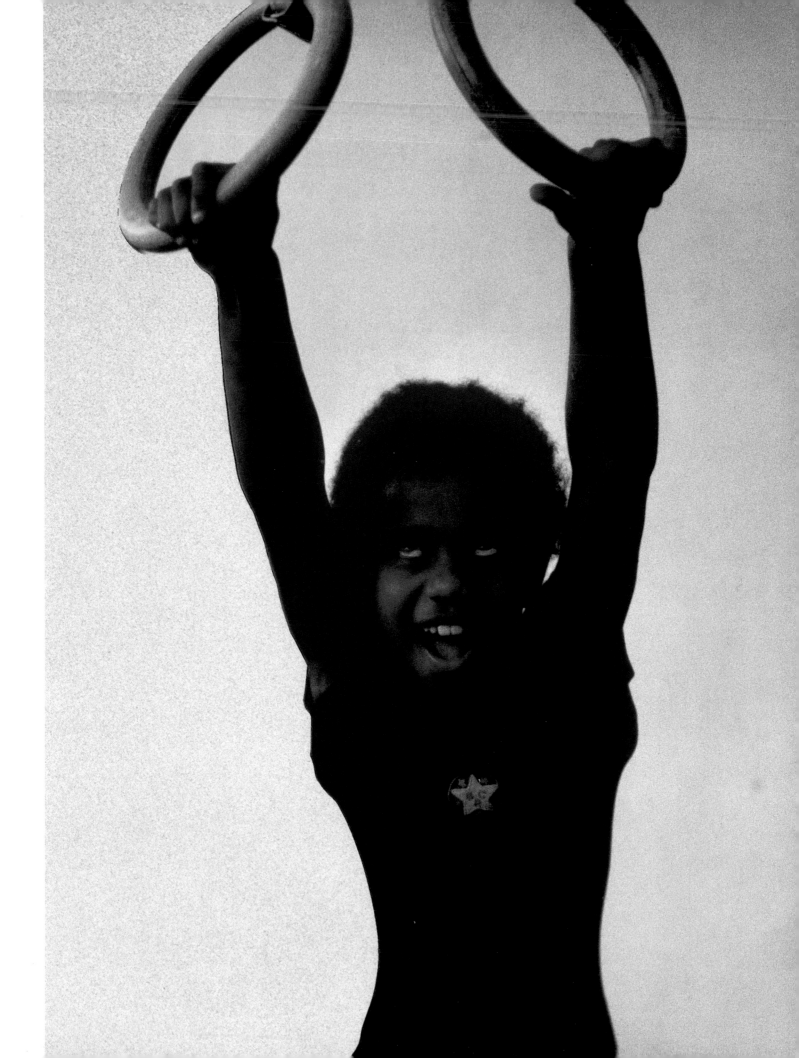

Rather than always cutting out the background in your pictures, it is sometimes worth including the location in your shots. The places that a child visits and lives in all contribute to memories of growing up.

# use the surroundings

▽ **Queen of the castle**

The janitor's daughter poses outside the French chateau that is her home. I shot from a height that guaranteed her head did not overlap with the front of the castle.

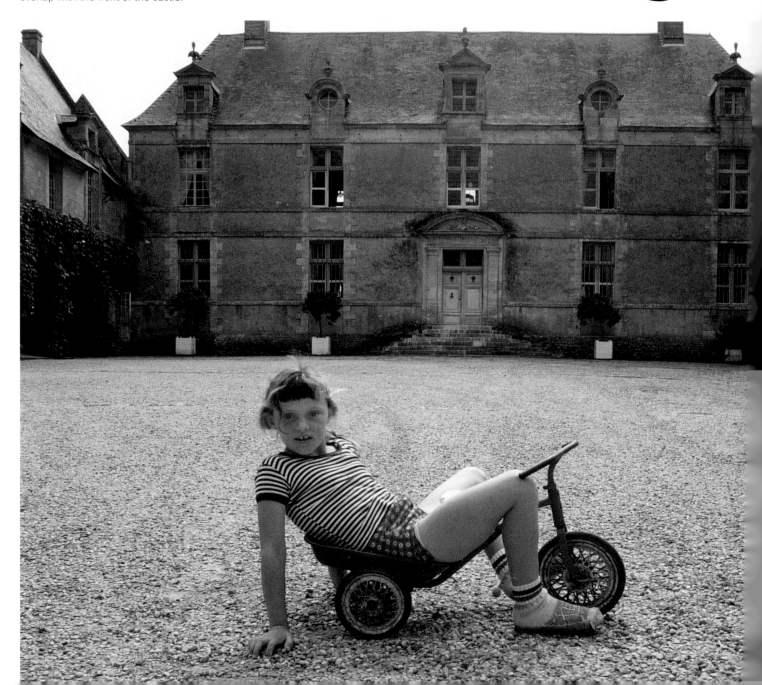

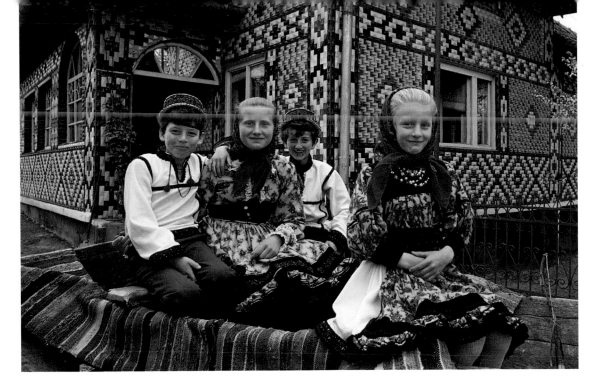

◁ **Pattern of life**

I was fascinated by this Romanian family who had covered their timber house in plastic tiles to create an intricate mosaic. The children were dressed up in national costume for a party, and I encouraged them to pose in front of their home. The two elements of the photograph clearly show the importance of pattern in these people's lives.

For centuries, artists have used the surroundings to epitomize the status of the people whose portraits they paint. The duke in front of his grand mansion is shown accompanied by all the trappings of his wealth and position.

This tradition still carries on through photography, but you no longer have to live a palatial lifestyle to be portrayed in the environment where you live or work.

Including a home, school or favourite childhood haunt in the background of a portrait adds more detail to the picture. It provides information that you and the child will be glad to be reminded of in years to come. However, as we have previously discussed, including such details can over-complicate the composition. But if our albums consist solely of pictures of faces that fill the frame, then your pictures could start to look very similar. Including the setting, therefore, adds variety to your growing portfolio. Do still try to avoid an over-complicated backdrop, so that the emphasis in the picture is not lost.

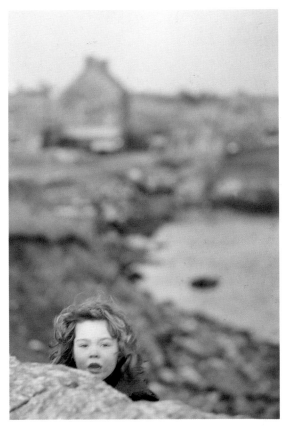

△ **In the wilds**

This girl popped up from behind a wall whilst I was taking pictures in the remote islands of Scotland. Rather than zooming in close on the astonished face, I used a wider lens setting to suggest the harsh conditions in which the child was growing up. However, I used a wide aperture so that this background was slightly out of focus and therefore did not take over the picture.

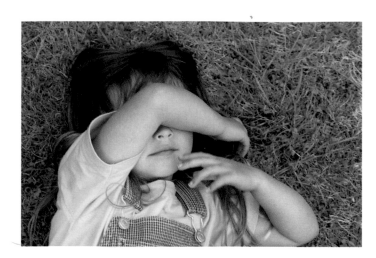

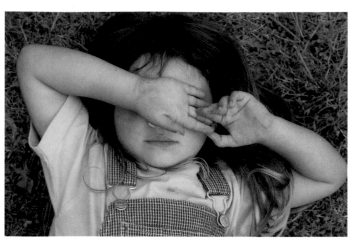

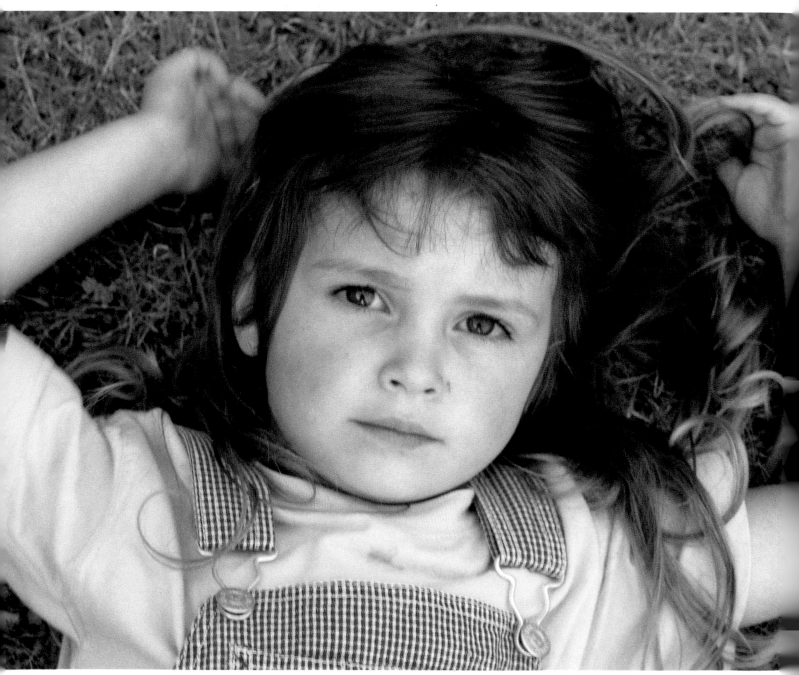

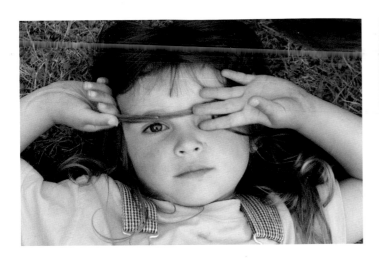

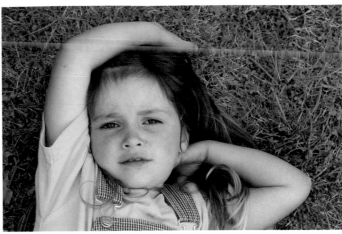

△ **Breaking down the barriers**

Often you will find that seemingly unwilling photographic subjects are, in fact, just a bit shy. At first the young girl in this series just lay on the ground, hiding her face from me and the camera. However, by carrying on taking pictures regardless, and encouraging the child rather than cajoling her, I was gradually able to gain her trust and cooperation.

Taking a series of similar pictures doesn't just help maximize your chances of getting a great picture – the extra exposures can also help break down the shyness of your young subject.

# take more than one shot

△ **Worth the wait**

Don't think of taking extra shots as a waste of film — think of it as an investment. Here, the extra film and patience have paid off, providing me with one great shot of the young girl.

One of the best ways to guarantee getting better portrait pictures is to shoot more film. It might seem extravagant to take more than one exposure of a particular pose or scene, but the additional frames should be seen as a way of ensuring success.

People's faces can change in a fraction of a second, and you can never be sure that you have captured the right expression until you see the final results. A carefully-arranged portrait can be ruined if the subject blinks just as the shutter is fired. Taking several shots helps avoid these unavoidable mishaps – and if all the shots should turn out successfully, you will have a ready supply of prints to give to relatives and grandparents. If you are using a digital camera, the less successful pictures can be deleted, giving you more memory for further pictures.

Sometimes, the practice of shooting additional shots can help the subject to relax and to look more natural in front of the camera. Even children who are normally willing subjects can suddenly become shy, or want to pull faces; by continuing to shoot, even though they are not posing in the way that you really want, you can break down their resistance and bashfulness.

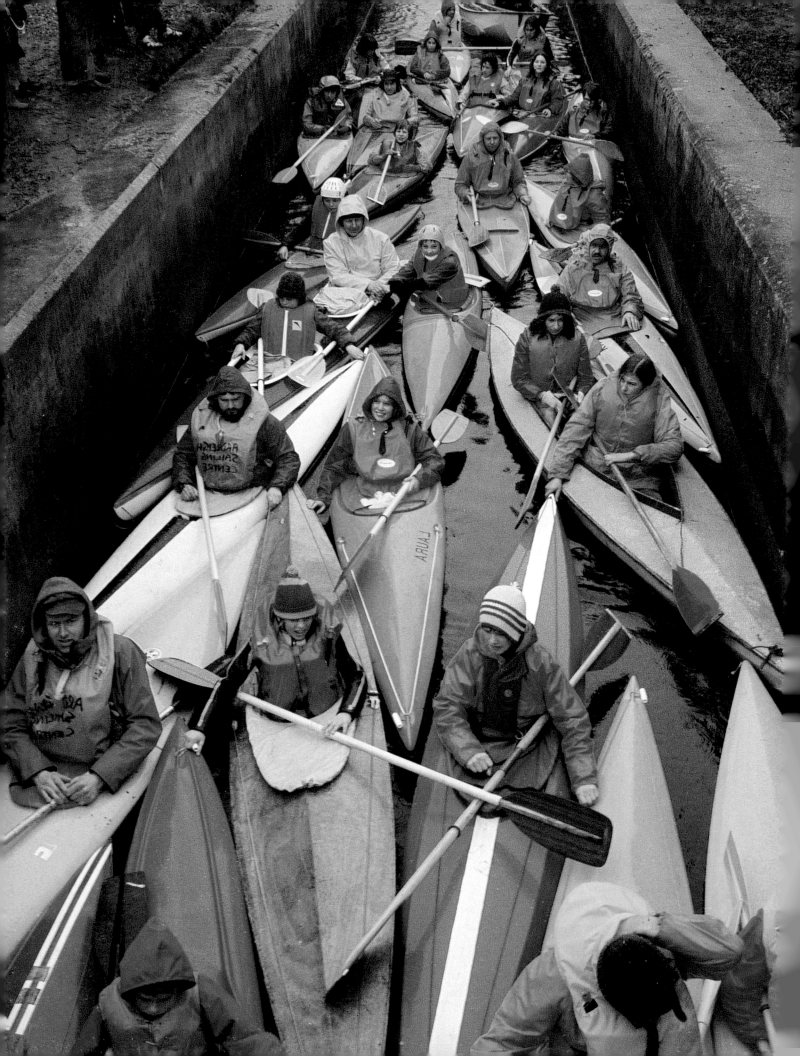

Whether they clash, contrast or tone together, colours have a powerful affect in your pictures. A peaceful shot can be turned into a dramatic one, just through the colour of shirt your child wears!

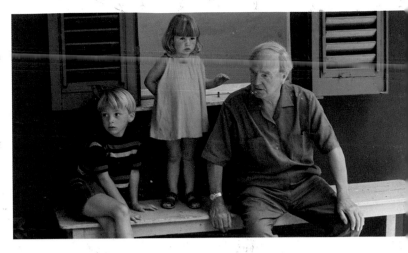

# using colour

Some colours attract the eye in a picture more than others. Reds, in particular, grab the attention of the viewer to such an extent that they can make small elements leap out of the picture. Other colours, such as blues, are more passive, and have a tendency to blend right into the background.

The way in which colours end up being combined in the frame has a major influence on how the shot turns out. Some colours, of course, will clash, creating a discordant image. If the colours in the scene are from the same

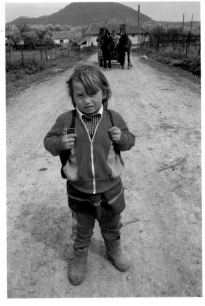

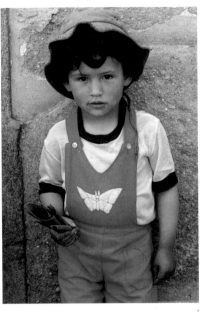

△ **Contrast**

◁ **River of colour**

In this shot, it is the riot of colour that makes the picture, not the individual identity of the canoeists. By using a wideangle lens setting, I have squeezed as much of the psychedelic scene into the frame in as possible. At the same time, my viewpoint has accentuated the converging lines of the sides of the canal.

palette, they will tone together, creating an image that is more restful on the eye.

Of course, in many cases it would seem that you have little choice in colours. But if your child is dressed in an orange dress, it may well pay to avoid framing them against a purple backdrop. Similarly, with young children you have control over what outfits they wear and can choose one that will work best in the surroundings you have in mind. A plain colour is always a safe choice. You can still suggest the clothes older children could wear – though you might not always get your own way!

In these pictures, the colours of the children's clothes help them to be plucked from their surroundings. However, some colours are more forceful in others: the child dressed in red (above left) leaps from the page, whilst in the shot of the boy in blue dungarees (above right) the effect is much more subtle. In the group portrait at the top of the page, the selection of pastel shades ensures that the colours complement each other rather than clashing.

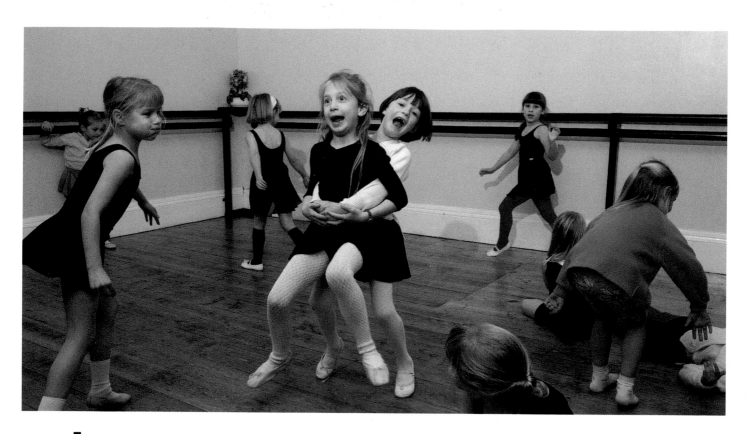

# playing up to the camera

Sometimes you have to forget you are a parent when you take photographs of children. When kids are boisterous and loud, they are often at their most natural; it's an element of childhood that has as much right to be featured in your album as any other.

Children will be children, and therefore are likely to want to play around at any opportunity that is presented to them.

Whether it is at the beginning of an organized activity, such as a dance class, or in the freedom of their own garden, kids will indulge in horseplay. To do so is part of growing up, and therefore should be included in your album of pictures, in just the same way as any other typical childhood activity.

You should also be aware that your presence, and that of the camera in particular, is likely to provoke this kind of exuberant behaviour. My advice, as a photographer rather than as a parent, is to indulge them. Their unrestrained running around and showing off will frequently produce very good pictures which are full of life and successful in capturing the sheer enjoyment that is part of childhood.

## ◁ Running riot

Before the dance lesson begins, the girls let off steam by running around the hall. It is a weekly prelude to the discipline and rigour of the class itself. That the camera is present just makes the behaviour more outlandish than usual.

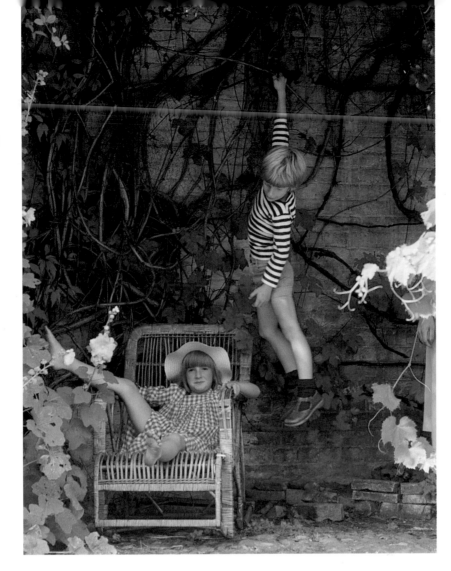

## ◁ Sibling rivalry

Brother and sister seem to compete with each other to see who can behave in the most wanton fashion in front of the camera. This is the sort of picture that the children will probably be embarrassed about in later years, but a great one to share with close family members.

## Useful tips...

• Don't zoom in too closely with this type of picture. You need to see the surroundings to fully understand what is going on – and a more messy composition adds to the feeling of chaos.

• If you want more sensible poses, let the kids let off steam first. Shoot them showing off, and then they might be more willing to be cooperative later.

• Let kids see the prints of them acting up to the camera. They'll love to show them to their friends.

## ▷ Tea for two

At first glance, the two girls look as if they are acting perfectly naturally and normally. In fact, they too are showing off to the camera, pretending to be as ladylike and grown-up as they possibly can. Although I used a long lens, the girls were aware of my presence and were not going to carry on their secret conversation in my earshot, so instead they acted a part.

Forget about the rulebook – some of the most interesting photographs that have ever been taken are the ones where the usual conventions of composition are abandoned. Don't be afraid to experiment – or to copy the ideas of others.

Photography has many conventions which suggest the best ways of arranging elements of your picture within the confines of the frame. These rules of composition, in many cases, are the same as those that have been used by artists for hundreds of years. But these rules are not meant to be religiously observed – they are merely guidelines. It is always worth experimenting, even if

# unusual compositions

▽ **The eyes have it**

The boy has heard a conversation behind him, and turns to look. Although his face is partly obscured by the back of the chair, the composition gives great prominence to his peering eyes.

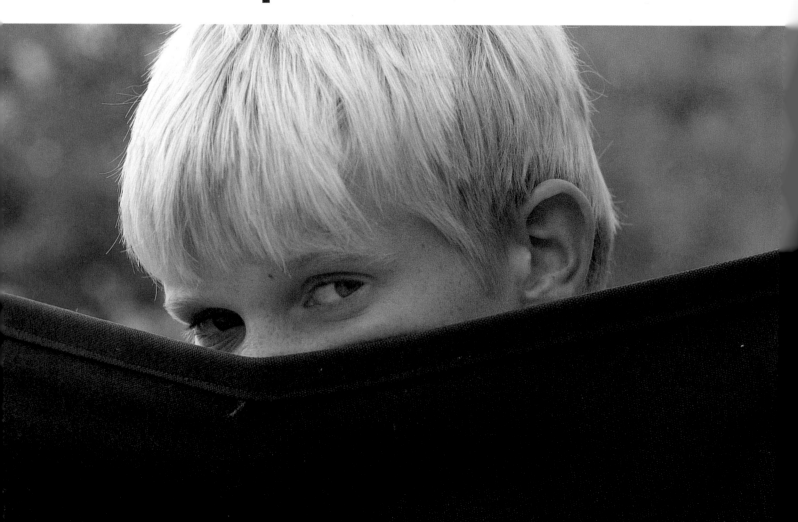

this means going against the usual recommended practice.

Normally, for instance, I avoid placing a person dead centre of the frame, because such a composition tends to look staid. Usually, the picture looks better if the child is slightly to one side of the picture. However, sometimes a symmetrical composition suits the surroundings. Similarly, I tend to avoid putting the main focal point of the picture right at the edge of the frame, but such radical framing can be used to create a deliberately provocative pose.

As a photographer, I don't go out of my way to shoot unusual compositions: they tend to be arrangements that you see before you and do your best to capture on film. To get into the habit of learning to be more adventurous with your composition, you could start off by recreating some of the photographs that you like in this book.

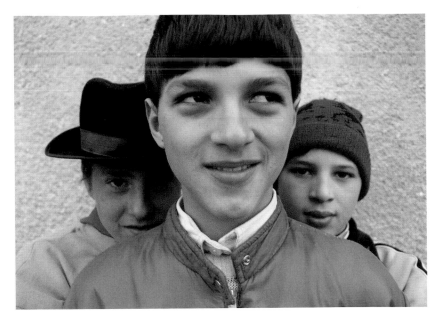

## Useful tips...

• Look out for natural frames in which to place your subjects. Stand a child in a doorway, at a window, or peering through a hole in a piece of playground apparatus.

• Try pictures where the face of the child is partly obscured – by a hand or a veil, say – but ensuring that the eyes stay both in view and in focus.

△ **Three friends**

Normally, I wouldn't attempt such a balanced composition when photographing groups. But here it developed naturally, as the two shy boys hid behind their bigger friend. The fact that two of the faces are partly obscured helps to make an interesting shot.

▷ **Double frame**

The little boy and the dog seem rather neglected and united in loneliness as they wait in the car. Here, the windows of the vehicle have provided two separate areas within the picture, creating frames within the normal frame of the picture.

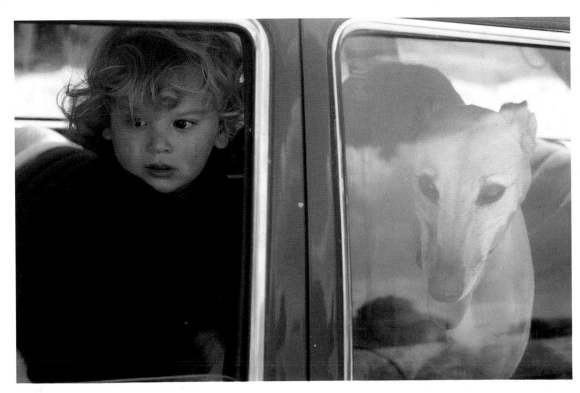

If you have a willing subject, don't just shoot a couple of pictures and give up. Explore the many different camera angles, shooting heights, poses and zoom settings, so as to add real variety to your photo album.

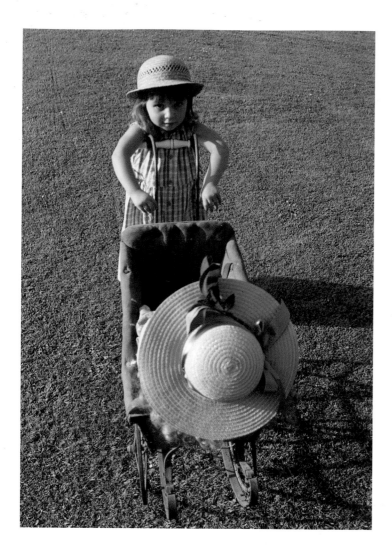

◁ **High ground**

Looking downwards at the girl from a grass bank, the doll's hat appears bigger than that of the girl's. This is because it is closer to the camera, and I have used a wideangle lens setting. The elevated camera position has a shrinking effect on the girl, making her appear smaller than usual.

# vary the pose

For every scene, there are a thousand different ways of capturing it on film. Children can not only move their heads, hands and feet in a multitude of ways to provide different poses; there are plenty of things that you can do to create a varied selection of pictures.

By adjusting your camera position, by moving around the child, you not only vary the background, but you also alter the relationship between different people and props within the frame. Even the smallest adjustment to the camera angle, in fact, can have a dramatic effect on the result. As well as changing your viewpoint, you can also vary camera height - this again alters the background, but can also have a shrinking or stretching effect on the child's height.

Those with a zoom lens at their disposal can choose whether to shoot from close-up with a wideangle, or from further away with a telephoto setting.

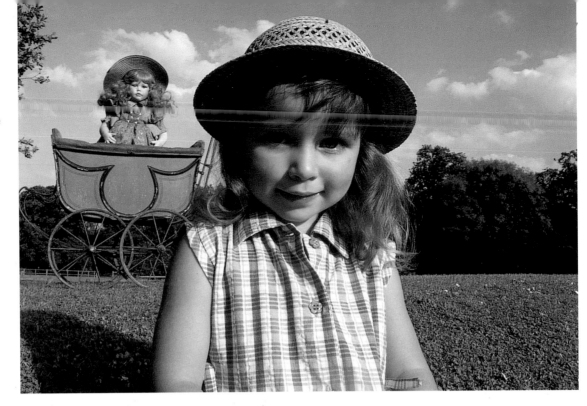

### ▷ Shift of emphasis

Shooting from the girl's eye level produces a more flattering shot. The doll and the pram have less emphasis in this shot, as they are further away – but, high on the bank, they still remain an important part of the overall composition.

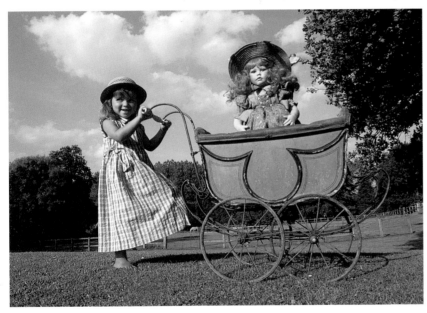

### △ Equal footing

A more conventional pose, where the pram and girl have equal emphasis in the frame. For this picture I lowered the camera below the girl's eyelevel, so that her head, and that of the doll, appeared clearly above the trees in the distance.

The size of the subject will remain the same, but the surroundings will appear completely different. Even with a fixed lens, you can still choose how much of the setting is included in the frame.

Not every pose and variation will produce a wonderful picture, but by exploring as many possibilities in the few minutes that a young model may afford you, you will increase your chance of great shots, and add more variety to your pictures.

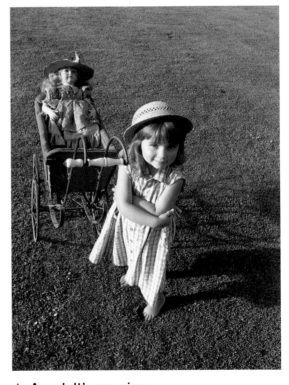

### △ An adult's-eye view

Again an elevated camera position, but unlike in the shot on the opposite page, the girl is closer to the camera than the doll, providing a more naturally balanced picture. By shooting from my own eye level, the grass has provided an unbroken background.

When shooting a moving target, you have two basic options. You can either freeze the subject in its tracks, or you can allow it to appear blurred to convey a sense of speed.

# capturing movement

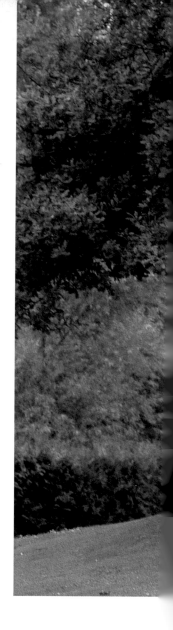

▷ **Show-off**

To capture this boy's daredevil antics, I used a shutter speed of ¹⁄₁₀₀₀ sec to freeze the action. However, so that the swing actually looked as if was moving, I waited until the angle of the swing was at its most dramatic. Additionally, I framed the shot loosely to show the boy suspended in mid-air against the idyllic setting.

◁ **Moving camera**

Here, I swung the camera round as I shot the picture, creating a blurred background. Meanwhile, the boy on the screen is caught relatively crisply using the compact camera's built-in flash.

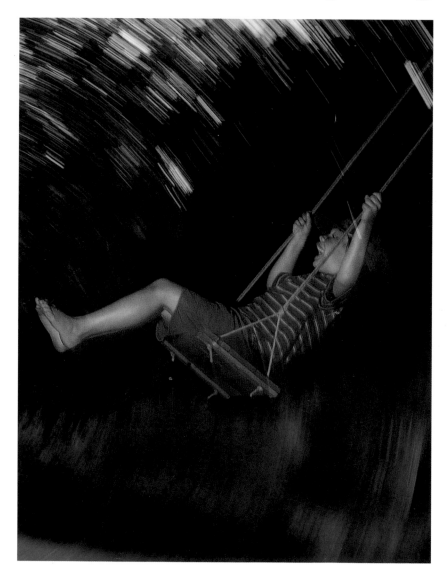

To photograph moving subjects sharply you need to use a fast shutter speed. The exact shutter speed that you choose not only depends on the speed of the subject, but also the direction of movement. If the child is running across the frame, a faster shutter speed is needed than if they are running directly towards you. Modern SLR cameras usually give you a range of speeds of up to ¹⁄₄₀₀₀sec to choose from – although for most moving kids a speed of ¹⁄₅₀₀sec or ¹⁄₁₀₀₀sec is sufficient.

The trouble with using fast shutter speeds is that you may not be able to tell from the picture that the child was

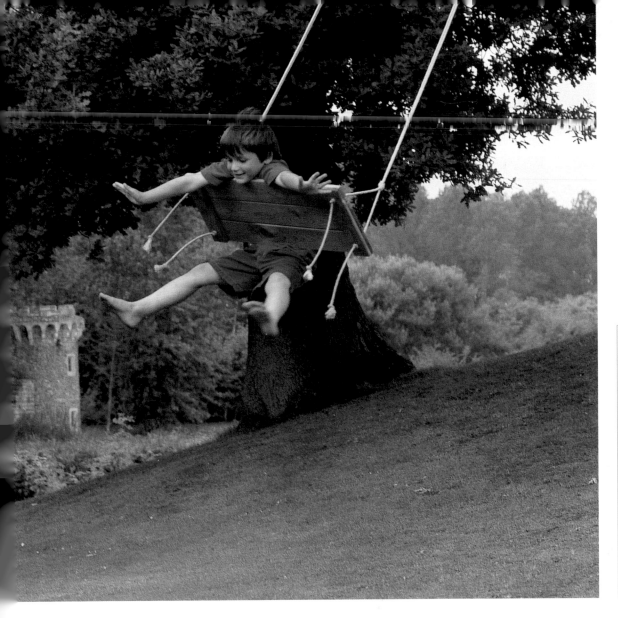

Useful tip…

• Experiment with different shutter settings when using the slow speed approach. Too much blur, and the subject is unrecognizable; too little blur, and it looks like a mistake.

moving in the first place, so you have to pick your moment to fire the shutter, so that the composition itself conveys a sense of speed. Instead, you can deliberately use a slower shutter speed, so that some of the picture is blurred, giving an artistic portrayal of movement.

Many compact cameras offer little control over the shutter speed or information as to which setting is being used. However, the flash can be used, even in daylight, to give an effective high shutter speed that can be as short as $\frac{1}{40,000}$sec. Unfortunately, you will not be able to shoot moving subjects from any distance with this technique.

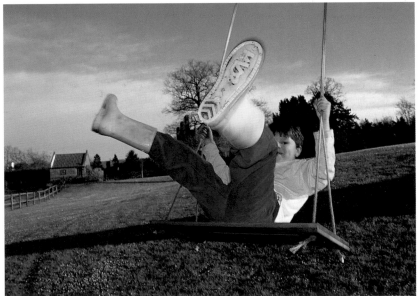

△ **Frozen with flash**

The best way to guarantee a fast shutter speed with a compact camera is to switch on the flash and get as close to the moving subject as you can.

building a
picture album

▷ **Birthday suit**

Forget the baby clothes – newborn children can often look better in photographs without any clothing hiding their folds of flesh.

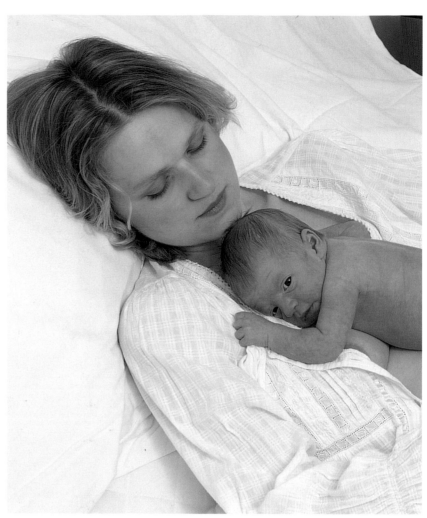

In the excitement of visiting the newest addition to your family, don't forget to take your camera to the hospital!

# baby's first day

The birth of a child brings with it a mass of emotions for all of those concerned. There is the relief of the parents that everything has turned out well. There is the exhaustion of the mother. And there is the sheer joy in the miracle of life.

With so many people to tell the news to, the preparations at home, and the sleep to catch up on, it is easy to forget the camera on your first visit to the hospital. But pictures of the newborn babe are the essential beginning to a new photographic album.

One of the main worries when shooting young babies is whether or not to use flash. Sudden bursts of bright light can disturb a resting child, so it

## Photographing new-born babies

### do's...

• Do get your camera kit ready in advance.

• Do ask permission to use flash. If you can't, use a super-fast film, such as ISO 1600.

• Do photograph the baby with each of its family – father, grandparents, brothers and sisters. These first meetings are priceless additions to the family album.

### ...and don'ts

• Don't include hospital clutter in your pictures. Try to frame the baby against white sheets, and crop in tightly, keeping the ward out of the picture.

• Don't get in the way of nurses, doctors and other mothers – they have important work to do.

• Don't keep mother and baby posing for too long. Both need to rest after their long, tiring time.

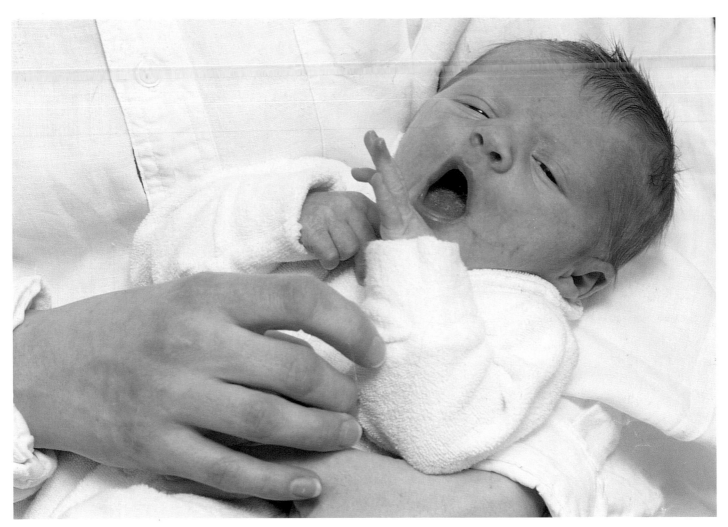

△ **Sense of scale**

Young babies do very little else but sleep, eat and cry! When you catch them doing something else, make sure you are ready to press the shutter. This yawning youngster makes a lovely study. Note that the close crop juxtaposes the size of the baby's hands with those of its mother, giving a real idea of scale.

may be worth trying out the range of high-speed films that are available (ISO 1000–3200). These will allow you to shoot perfectly presentable pictures with the available light in the maternity ward, bedroom or nursery.

Babies rarely look at their best just after they are born, with the skin appearing very red and battered. It takes a few days for a baby's beautiful complexion to develop.

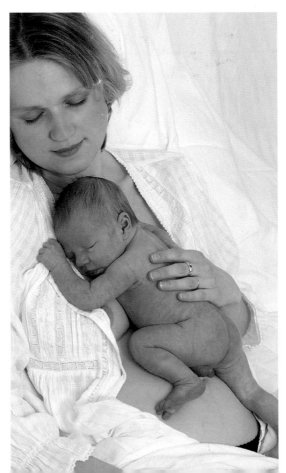

▷ **A special bond**

A picture of a mother cradling her newborn child shows the fragility of a young baby. It also helps to emphasize the beginning of a special bond between the two. Such shots are also invaluable for reminding the parents, over the following months, just how fast the baby has grown.

Alongside the weight charts, make sure that you also keep a regular photographic record of the baby's development. Always keep the camera to hand, as you don't want to miss any of the important stages in those early months of rapid change.

# babies

◁ **Let babies lie**

Shooting young babies from above, as they lie on the ground, will ensure that you can get pictures with a plain background. Here, I laid a sheet of black velvet on a bed for the baby to lie on.

▷ **The family seat**

Young babies cannot sit up unaided, but if you prop them up in a chair or on a sofa they suddenly look older than they are. Ensure that someone is just out of sight, to catch the baby should they begin to topple. Here, the young heir to a dynasty is watched over by a slightly older ancestor.

The arrival of a baby in the house provides so many new responsibilities for the parents, that it is easy to forget about photography. However, in the first few months babies develop new skills practically every week, and so you must make a conscious effort to use your camera as often as possible. It might even be worth writing a chart, to ensure that key events are ticked off: the first weigh-in, the first bath, the first smile, and so on.

In the early months, babies do little more than sleep, eat and cry, but although these are routine activities, they are essential parts of a baby's life. Those early moods, the feeding sessions and the formative play sessions should all be recorded for posterity. Remember, the baby will change very quickly – and you can't go back and reshoot pictures that you forgot to take at the time.

Young babies, of course, can do very little for themselves, and therefore it is well worth having an assistant to hand to tender to your subject's needs. Your partner would be the obvious choice, or, if the baby is not your own, then the mother or father. Your helper will not only be able to help entertain and reassure the baby, but he or she will also be able to watch out for the baby's safety more effectively than someone who's concentrating on the viewfinder. The assistant's other vital task is to keep the baby's face dribble-free for the camera!

## Useful tips…

• Keep a spare set of clothes close at hand – as well as the changing bag.

• The mother should keep talking to the baby throughout the session – the sound of her voice will reassure the baby.

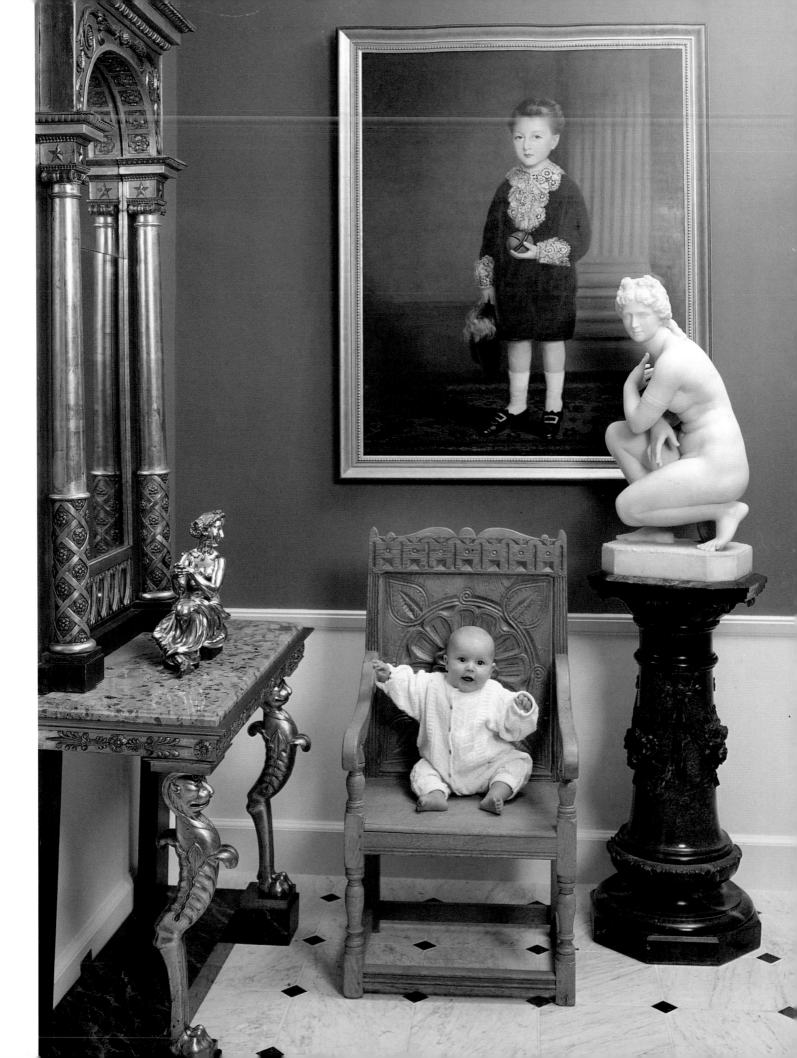

From baby to toddler, learning to walk marks a major milestone in a child's life. But the new skill brings increased independence, allowing him or her to make their own discoveries in the world around them.

# first steps

The exact age at which a child will take his first tentative steps as a toddler varies enormously from child to child. Some ambitious, muscular babies will start striding out at nine months, whilst others will crawl around quite happily and healthily until they are 18 months. For most, however, the progression to two limbs from four occurs sometime around or after the first birthday.

Starting to walk is seldom a sudden thing; children will first learn to stand unaided, and will gradually take an increasing number of steps. However, the learning stage rarely takes more than a matter of weeks. Being such a momentous achievement, in the child's

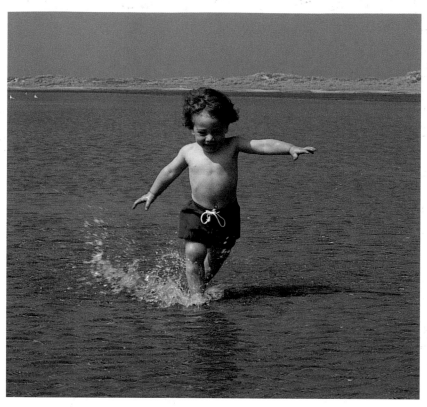

△ **Walking on water**

A 15-month-old boy, who has only recently learnt how to walk, makes his first visit to the seaside. To capture his variety of expressions as he steps into the sea for the first time. I deliberately didn't zoom in too tightly, so that the context of the picture was obvious.

eyes as well as that of his or her parents, it is one that you will obviously want to catch on film. The classic approach is to get the child to walk towards you and the camera as you shoot away – capturing the inevitable fall, as well as the look of triumph on the child's face as it makes it to your arms. An equally rewarding alternative is to take shots of the child walking into the arms of a grandparent or parent.

With the skill learnt, children become increasingly independent, toddling off to explore the new places that they visit. Inevitably, they will now be seeing things for the first time every time they go out, whether it is the beach, tractors, horses or trucks. They will show different and unpredictable emotions on such occasions – and photographing these first meetings can often produce memorable images.

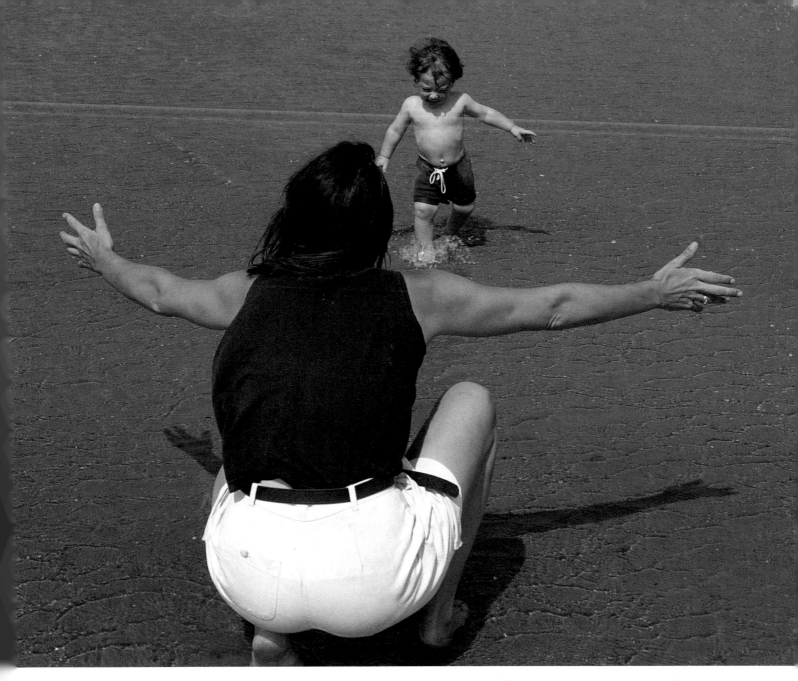

## Useful tips…

• Try crouching down low as the child walks to you, exaggerating their height above ground level.

• Shoot in a wide-open space, so as to have a clear, uncluttered backdrop.

### △ Into mum's arms

Shooting from over the shoulder of the mother provides a powerful way of showing a child's early walking and running experiences. A wideangle lens setting exaggerates the size of the parent's welcoming arms.

### ▷ A parent's praise

Don't just shoot the action, shoot the reaction as well. After his journey, the boy gets a hug and words of encouragement from his mother.

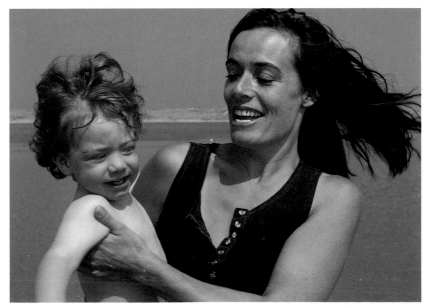

▷ **Hand in hand**

Sunny days are childhood days, and a day at the beach provides the space and the freedom for the whole family to relax. Use a friend or relative to ensure that parents and children can be captured together in a happy pose.

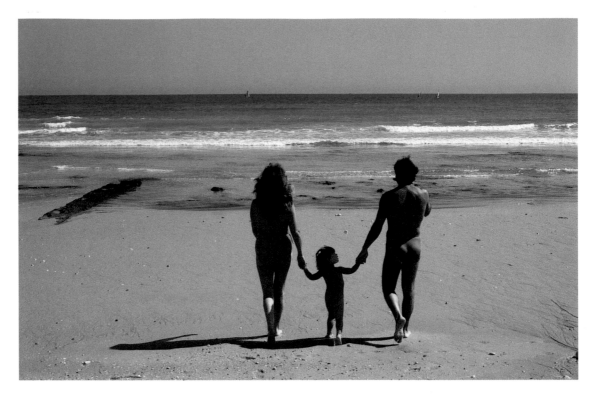

# with mum and dad

It goes without saying that children have a special relationship with their parents. But if your offspring are always pictured on their own, this developing bond will be missing from your photographs.

From the day they are born, children are totally dependent on their parents, who feed them, clothe them, protect them and nurture them. For most of the time, at least, children are a great source of pleasure and enjoyment to the mother and father. However, if you look through many people's pictures of their offspring this relationship rarely shows through, other than in the obvious pictures taken at birth, at baptism and so on.

The problem is that most people photograph their children in isolation – either completely on their own, or with friends, or with their brothers and sisters. By looking at these pictures, it is as if the children have grown up separated from their parents.

You should therefore make a conscious effort to avoid this, because the warm, loving relationship within a family can be so easy to capture on film, and makes such a wonderful addition to

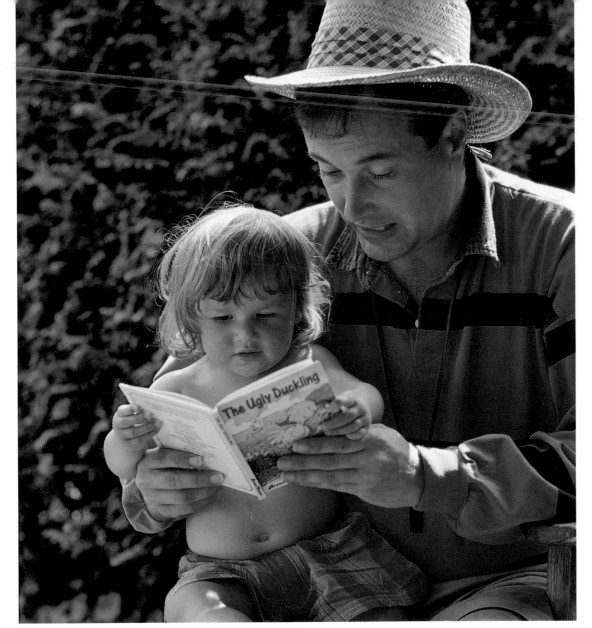

◁ **Once upon a time**

A story before an afternoon nap provides an ideal time to capture father and son involved in something together. Despite the backlit conditions, there is enough reflected light from the ground and from adjacent buildings to illuminate the two faces evenly.

your photographic record. A good place to start is with everyday tasks, with the children 'helping' around the house, whether it is with the washing up, cleaning, or doing the gardening.

However, the best time to get intimate shots of father and son, mother and daughter, and so on, is when the family is on holiday. With fewer chores and responsibilities, the adults should be more relaxed, and hopefully will appear so in the pictures.

Do also make sure that the photographer of the family also gets into more than just the occasional shot!

▷ **Swing time**

The simple games that a mother and her child might play every day can produce a brilliant action shot. On a beach, of course, the large expanse of space means that the background can be much simpler than if the picture had been taken in a small garden.

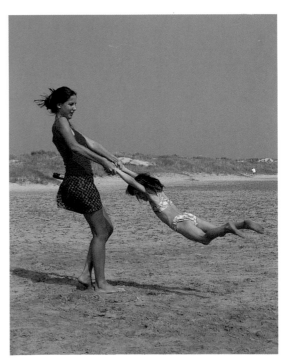

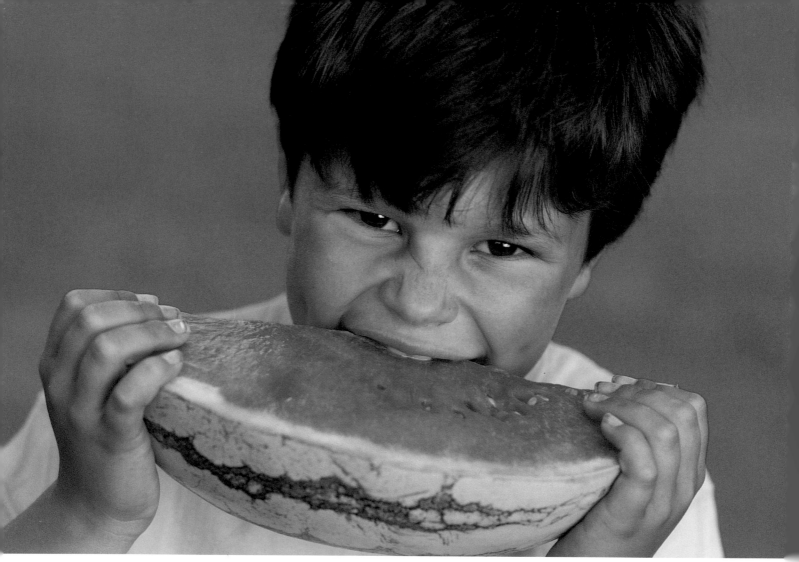

△ **Big mouth**

Huge portions of food can produce hilarious images. The classic shot of a boy eating a watermelon cannot fail to create a strong picture, as the red flesh and mouth-like shape of the fruit catch the attention.

# open wide

Some parents may deliberately avoid taking pictures of their children whilst they are stuffing their faces – but such undignified scenes are typical of children, and can produce very amusing photographic studies.

Eating is one of the key subjects for child photography which can't be missed. However, many photographers avoid such pictures, because most people, let alone children, look far from their best with their mouths full. But you can't escape the fact that eating is so central to children's existence. As babies, they demand to be fed at all hours, and once they go through growth spurts at school age, they demand snacks morning, noon and night.

Obviously, with less than perfect table manners, many children can look particularly gruesome whilst filling their stomachs, so you may need to pick the exact scene, and the precise moment you shoot, with extreme care.

However, if you find the right setting and the shot is well composed, without too much unnecessary detail, then the picture can be enjoyed by even the most fastidious friend or relative.

One of the best ways to take successful pictures of children eating is to aim to get an amusing image. The classic shot is of a child whose face is covered in chocolate or ice cream. As long as the child is 4 rather than 14, most people will find such pictures both charming and typical.

Another funny picture is to show kids with enormous portions – holding a rack of ribs, a whole baguette sandwich or giant knickerbocker glory. Showing them trying to tackle such things, even as a joke, can produce dynamic pictures, simply because of the juxtaposition of a small child with the extra-large meal.

## ▷ Sticky moment

Ice cream and toddlers are a potent combination, always guaranteed to make a messy face which contrasts with the look of enjoyment. Here, the ice cream has spread so far, it is hard to see where the pattern on the boys shirt begins and ends!

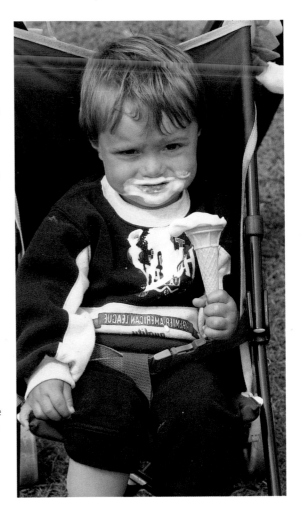

## ▽ Concentration

Children are often at the most calm and quietest when eating their favourite snack or sweets. Here, on a family day out, a boy appears lost to the world as he meditates while munching his crisps.

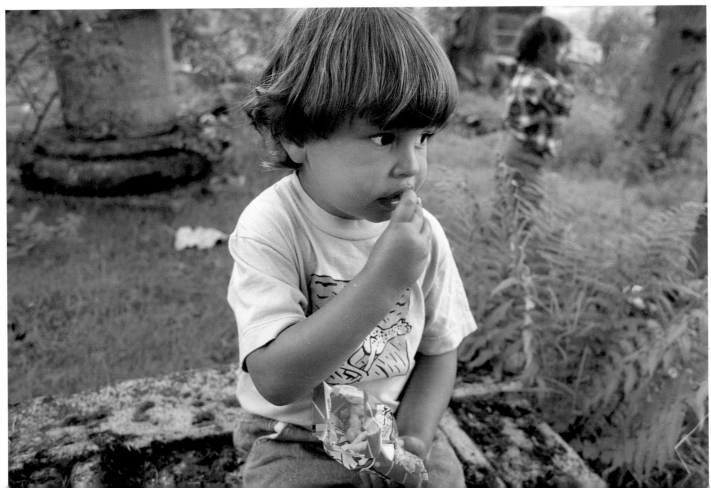

Young boys and model boats have had a strong affinity since the first sailors ventured to sea. Toy yachts and children of both sexes can produce timelessly photogenic shots at your local boating pond or paddling pool – especially if you use the ripples on the water as a patterned backdrop.

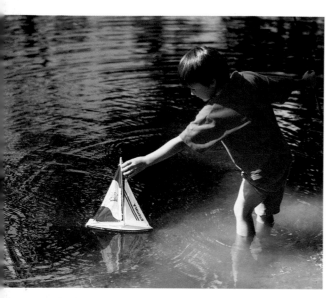

△ **Simplifying the background**

When taking pictures in public parks it is easy to end up with cars, rubbish bins and other distractions in the background of your pictures. Here, I stood on a bank, so that, from the elevated camera position, the pool creates a seamless backdrop for the sequence.

△ **Ripples**

In this picture, the pattern formed by the waves on the boating pond produces an interesting pattern which encircles the main subject. The low afternoon sun has helped to accentuate the effect, creating a strong shadow and bright highlight on each of the ripples.

# setting sail

Like father and grandfather before them, every young boy will appreciate the opportunity of becoming a master yachtsman for the day, as they trim the sails of their toy boat. And, of course, young girls will also relish the opportunity of playing the pirate captain or the swashbuckling explorer.

Part of the beauty of such pastimes is the timeless nature of the toy, which, unlike the skateboards and video games of modern toy shops, can help you to produce classic pictures without having to make too much of an effort.

Boating lakes are not such a common feature of parks as they were a generation ago, but they can still be found in many cities. If not, paddling pools, shallow rivers and coastal sandbanks can provide a similar setting. Yachts and battery-powered motorboats are still found easily enough at toy shops and beach stores.

Rather than shooting from down low, it is worth shooting from an elevated camera position for this subject. By doing this, the water's surface becomes the background for your shots. This not

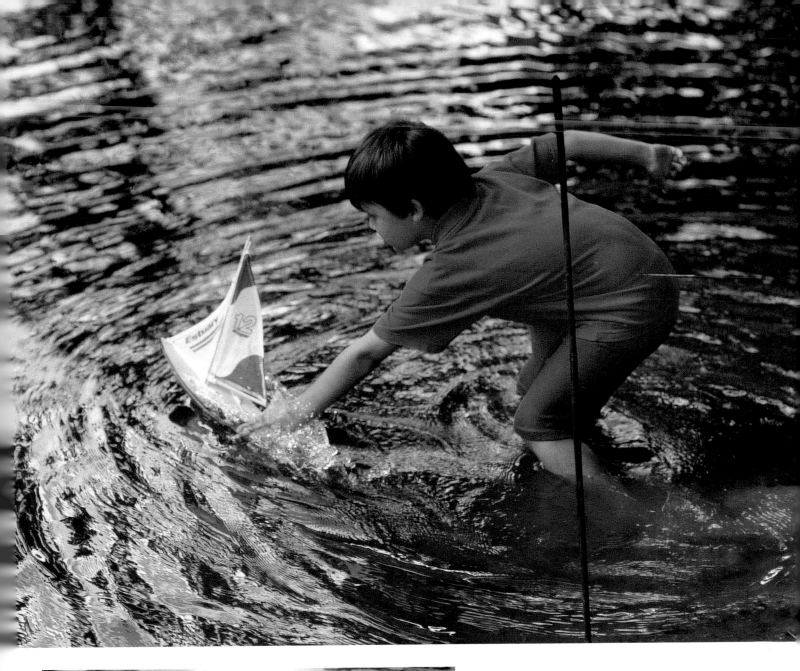

only cuts out modern-day distractions from the scene, but allows you to include the wonderful patterns and coloured reflections that form on any expanse of water. Look out for grass banks or benches that you could stand on to give yourself the added height, then follow the child with a telephoto lens as they daydream of distant lands.

◁ **Streak of light**

The bright areas in a picture are the ones that tend to attract the viewer's attention first. Here, the reflection of the sun makes a highlight, creating an arrow which draws your gaze to the boy and his boat.

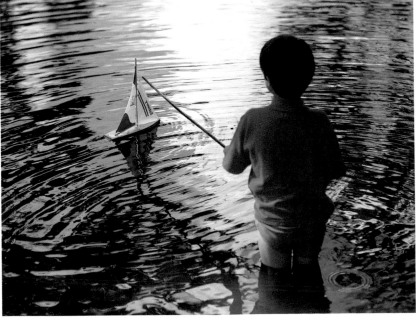

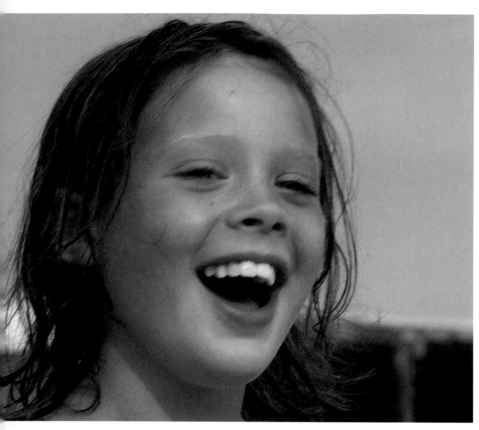

A child's face is an open book, with expressions that willingly tell you what he or she is thinking of at that precise moment in time. Every child has particular facial poses, that they pull when they are happy, annoyed or tired, and as long as you know the child well, these mannerisms will be easy to spot. Even uncharacteristic smiles or frowns are worth photographing if they produce amusing shots – a technique regularly practised by newspaper photographers when taking pictures of politicians.

▷ **Teamwork**

It is very helpful to have someone to attract the child's attention, amusing them as you concentrate on taking pictures at the exact second you have a typical pose.

△ **Be patient**

Don't shout at a child to get the pose that you want. If the session is too laboured, the child may well clam up. It is better to just wait and watch until the expression develops.

▷ **Watch the spectator**

One of the best times to capture a range of mannerisms is by 'secretly' shooting them from a distance whilst they are watching a puppet show or a favourite video.

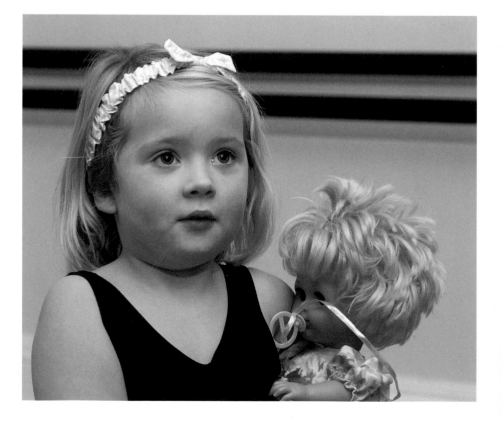

Children's faces can change so rapidly, that if you train your lens on them you can end up with 36 different shots in just a few minutes.

# expressions

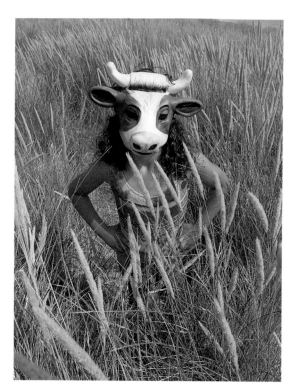

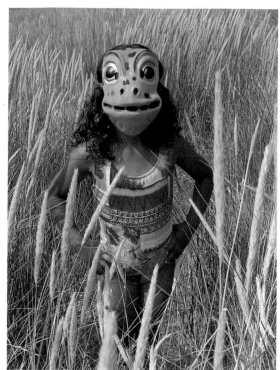

Masks and balloons are two great ways to add colour and shape to your pictures, and create fun for the children at the same time.

# simple props

In the theatre, props are an essential part of a good production. They not only help to explain what is happening on-stage, but also add much-needed visual interest. Props are equally useful to the photographer too; if they are chosen carefully, they can tell you more about the person in the portrait, and they can add a great deal of excitement and variety to the shot.

Professional photographers always look for things which can help explain a person's hobbies or profession. A picture of a clown has more impact if he is shown juggling balls, and a portrait of a chief executive of a supermarket chain is more informative if he is seen pushing a trolley full of groceries.

We can use the same trick when photographing children. The problem is deciding what prop to use out of the huge range of toys and possessions that children own. The best things to choose are those which are large enough so that they will be readily identifiable in a photograph. If you used a model train,

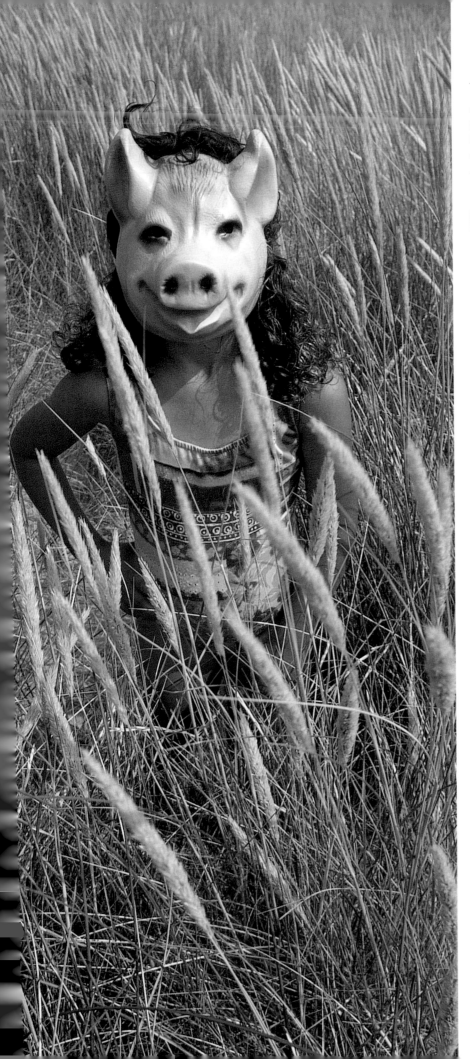

◁ ***Animal Farm* meets *Planet of the Apes***

A selection of animal masks from a seaside novelty shop provides perfect props for a fun photo shoot. The girl loved posing in the wild setting provided by the dunes, and the result is a surreal sequence that makes an amusing alternative to the usual holiday snaps.

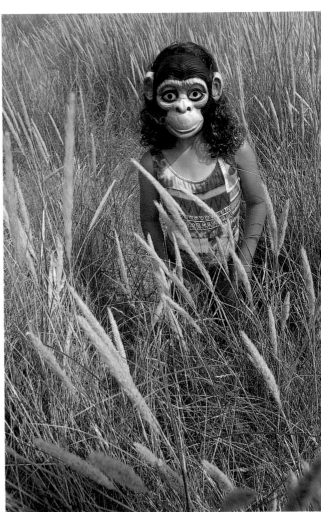

for instance, you would have to set the shot up in a way to ensure that you could see what it was in the photograph. If you use a giant cuddly rabbit, you have none of these problems.

Large objects with bright colours and graphic shapes are an ideal choice, as they are designed to attract attention. Shaped helium balloons, which can be bought at carnivals or from specialist shops, come in a mind-numbing

selection of shapes and sizes. Often children are given them as presents at birthday parties, and they not only find the larger-than-life designs appealing, they also love the way they rise up into the air. This does create problems, as any parent who has had to deal with a child who's balloon has risen out of reach and into the open sky will testify.

## Other suggestions to try ...

**Here are some other ideas for fun props that you could use in your pictures:**

- You can find some fantastic horror masks at toy shops and fancy dress stores. These would be great for a scary Halloween sequence.

- Similarly, masks can be bought of favourite cartoon characters – kids will love pretending to be these.

- Try sequences of children holding their favourite toys. Large teddy bears, cuddly animals or dolls are particularly good props – the bigger the better.

- Instead of balloons, use other inflatable shapes, such as giant blow-up bananas, mallets and dinosaurs.

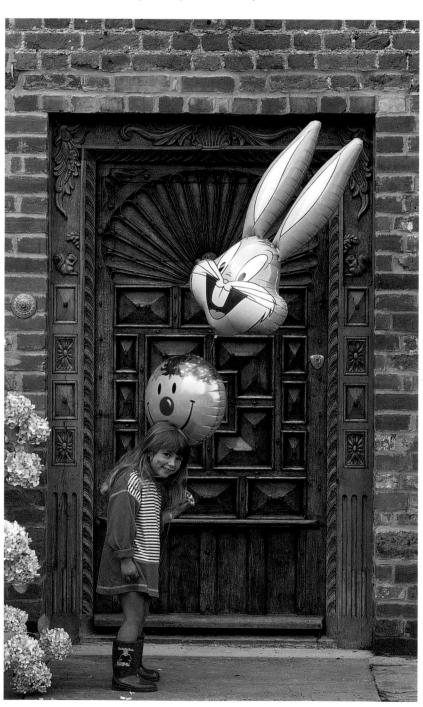

However, for the photographer in you at least, the creative possibilities outweigh the pitfalls.

Just as appealing to kids, and often available from the same stores as the helium balloons, are the wide variety of dressing-up masks that you can find. The best ones tend to be made of rubber or latex; alternatives, and almost as good, are the cheaper ones that use injection-moulded plastic. Put these on children, and you transform them.

Even teenage children will love to recreate themselves in this way – particularly if you can give them a choice of mask. As with all props, they work best when the child has had a say in what accompanies them in their portrait. The child then feels involved, and is more likely to be amenable to your posing suggestions.

### ▷ Larger than life

In this photograph I have tried to balance the three central characters in the scene: the girl, the smiling balloon and the cherub statue.

### ◁ Perfectly framed

It took me ages to get this pair of helium balloons to fit perfectly within the doorway – but I think the effort was well worth it, creating a frame within a frame.

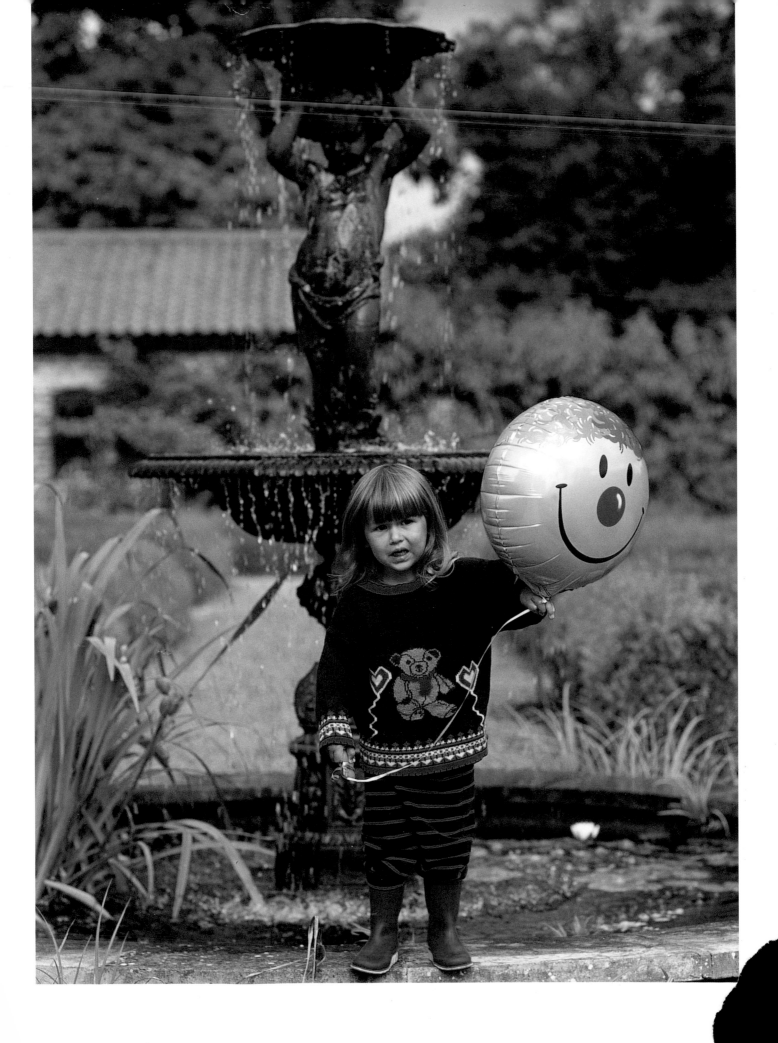

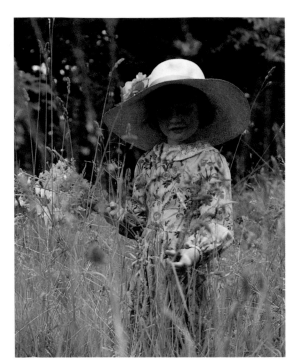 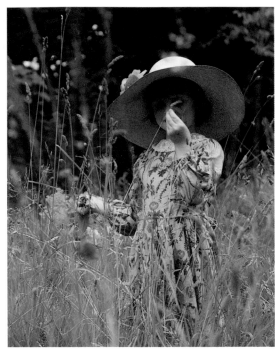

There are days when you can do no wrong, and every picture that you take turns out to be a masterpiece.

# magic moments

There are frequent occasions when you pick up the camera and you know that the pictures that you are going to be take will be less than perfect. The child is unwilling, the sky is grey, and the surroundings are uninspiring.

To make up for these occasions, there are days when everything you shoot turns out to be a superb photograph. The reason for this may not be just down to luck or a sudden surge in photographic talent. It might just be because your subject is particularly photogenic that day. Every child has weeks, or even years, when they are more photogenic than others. At a

particular time they are particularly radiant – they have no spots, the haircut is perfect, and their eyes are sparkling. If you then add a sunny day, an idyllic backdrop and an attractive outfit, it becomes hard to take duff photographs.

The secret is to recognize these occasions and capitalize on them. Don't give up because you have already taken a dozen frames – keep shooting. You may never have it so good again, and the pictures that you take that afternoon may well be the ones that get displayed on your mantelpiece or wall for many decades to come – or even win you prizes in photographic competitions.

▷ **Beauty and beast**

Even the family dog poses like a professional – this must be one of those days when everything goes your way. The pile of logs alongside a forest path provides a patterned backdrop, toning perfectly with the girl's dress.

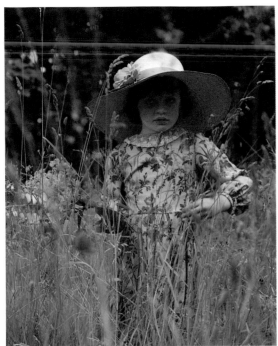

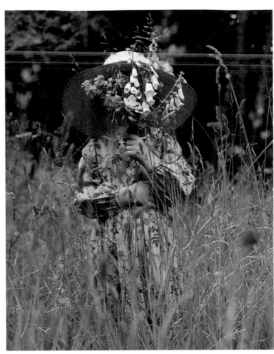

◁ **Summer stroll**

The combination of the flower-filled meadow, the Sunday-best dress, magnificent hat, and the warm summer's light creates a scene that practically guarantees superb pictures. If everything works together like this, you just can't stop yourself shooting.

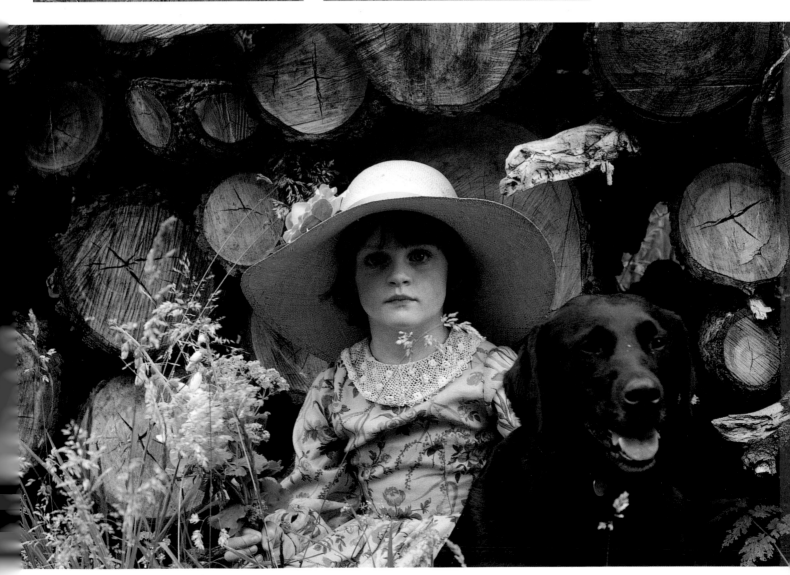

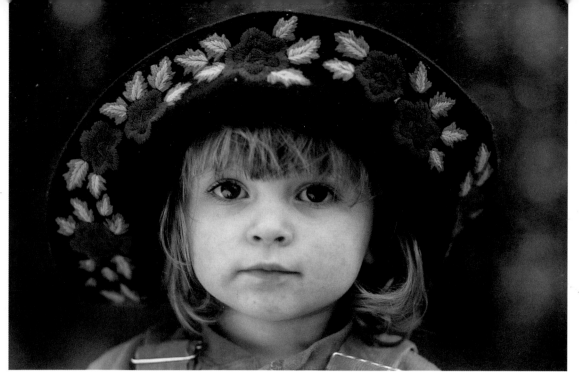

◁ **Matching colours**

Props can work particularly well when their colours complement, or match, those of the subject's clothes or the background. I particularly liked this hat on the little girl, as its green and red floral pattern matched the colour of her dungarees and shirt so perfectly.

Children love dressing up and showing off their wardrobe. Try using a selection of hats, or other types of headgear, to make an interesting photographic sequence that's fun for the kids.

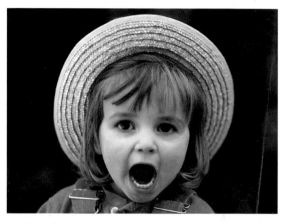

△ **Matching shapes**

This straw hat forms a circular halo around the girl's head. I emphasized this shape by getting her to shout, turning her mouth into a second circle.

# hat tricks

Useful tips...

• A white piece of card held just out of shot can be used to reflect more light under the hat brim.

• Make adult hats fit a child's head by stuffing the inside with newspaper.

Hats are not just a simple way to add variety to your pictures – the addition of headgear can perform a vital role in the composition. The beauty of the hat is that it creates a distinct border between the head of the person you are photographing and the background. At a stroke, therefore, a distracting background can be distanced, and partly obliterated, by the hat.

Additionally, a hat provides a strong graphic shape to your head-and-shoulder ᴄ  -ups: a circle, oval or triangle, depending on the design of the particular hat. Some hats, of course, can also be used to provide additional colour to the scene.

As with masks, children love to dress up in headgear – although the selection they will prefer will probably vary

### ▽ Vary the angle

Don't shoot all your shots with the subject facing the same way. Here, I asked her to look at something away from the camera.

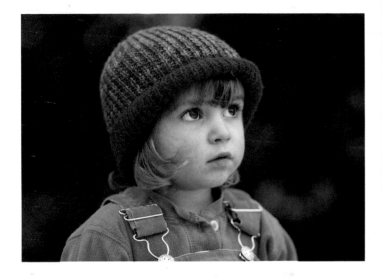

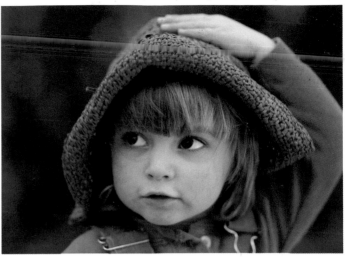

### △ Posing with hands

There are a thousand and one different ways for a person to pose in front of the camera. One of the ways in which you can add variety to your portraits is to get the child to do something with their hands, such as putting them on their head, or holding their face.

## Other suggestions to try...

**Don't worry if you don't have a wardrobe full of hats; there are lots of other ways to add variety to your pictures through the use of accessories:**

- Sunglasses are a fashion accessory that all children love to pose in. You could buy cheap pairs in a variety of colours and shapes for your pictures.

- Another prop that helps isolate the subject's head from the background is an opened umbrella or parasol, held by the child over their shoulder. Colourful golfing umbrellas are great for this.

- Young girls may have a good selection of headbands, bandanas or tiaras which could be used.

### ▽ Perfect framing

When framing the face of a person, it is important that the bottom of the frame does not cut through their neck, as this looks very unnatural. Instead, frame the shot so that it includes the top of the shoulders. Ideally, you should also leave a gap between the top of the head (or hat) and the top of the picture.

depending on the age and gender of your sitter. Young girls may be happy to pose with their mother's best bonnet, whilst boys may well prefer a baseball cap, fireman's helmet or cowboy's stetson. Children may well have a selection of their own hats in a dressing-up box, or for keeping them protected from the sun or the cold.

A further benefit on bright, sunny days is that brimmed hats provide shade for the facial features. This then avoids the strong contrast between highlights and shadows that can be a problem when using direct sunlight.

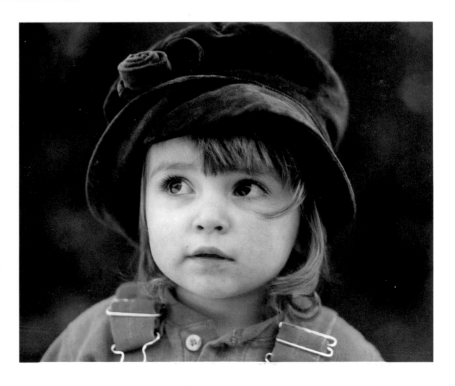

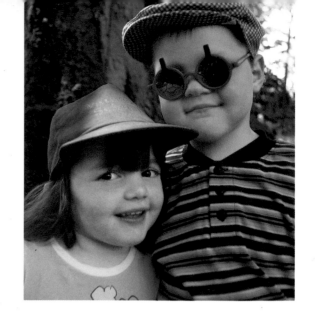

Arranging groups of children for a photograph is never straightforward, but when you are just including two people in the shot there are special considerations to bear in mind.

# two's company

The most obvious way to photograph two children together is to have them pose side by side, sitting or standing in a line. Although this is a perfectly natural arrangement, it rarely creates the most interesting pictures. If you use this composition, you end up with the two people in a line which stretches across the picture, running parallel with the top and bottom of the frame. The symmetrical arrangement that results may be suitable if you want to stress the facial similarities between two sisters, say, but to create a more dynamic picture you need to use a composition that is more off-balance.

One of the easiest ways of doing this with two people is to arrange the shot so that the imaginary line created between the two people's heads forms a diagonal line running across the frame. In other words, you need one head in one corner of the picture, and the other head in the opposite corner. To do this the two heads either need to be at different

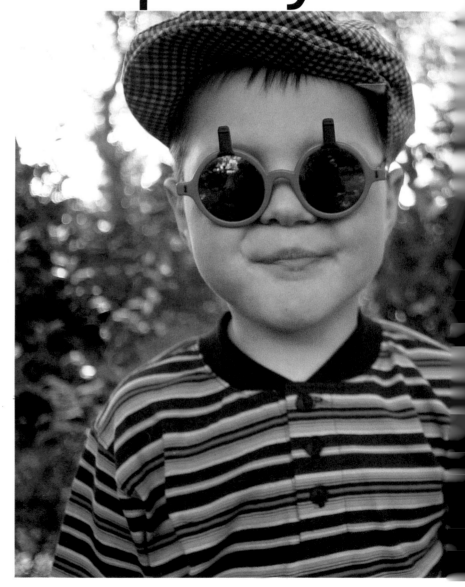

### ◁ Big brother

By cropping in close, I have exaggerated the difference in height of the two children, so that the boy towers over his sister in a protective way.

### ▷ Stand in line

The conventional way of photographing a group, with the children standing next to each other. This arrangement is not as dynamic as the other compositions shown on these pages.

### ◁ Diagonal force

With the two children at slightly different distances from the camera, the boy becomes the dominant person in the frame. The girl becomes a supporting act, looking on proudly or anxiously at her brother. A diagonal arrangement of the two subjects creates a much more pleasing composition that having the two in a straight line.

### △ Fair's fair

When photographing two or more children, try your best to give equal attention to each of them. In this shot the young girl gets her chance to be downstage in the picture, whilst the brother gets the walk-on part. She gleams with pleasure at getting her big break!

heights, or better still, at different distances from the camera. With your subjects at different depths, you automatically put an emphasis on the person who is nearest the camera – and although this might seem like showing favouritism, it creates far more interesting pictures. So one child doesn't feel hard done by, swap the two around for some of your shots.

You don't need to see the face of a child to get an interesting picture. Shots of feet on their own can produce interesting close-ups in their own right, and can also show the speed at which kids grow up.

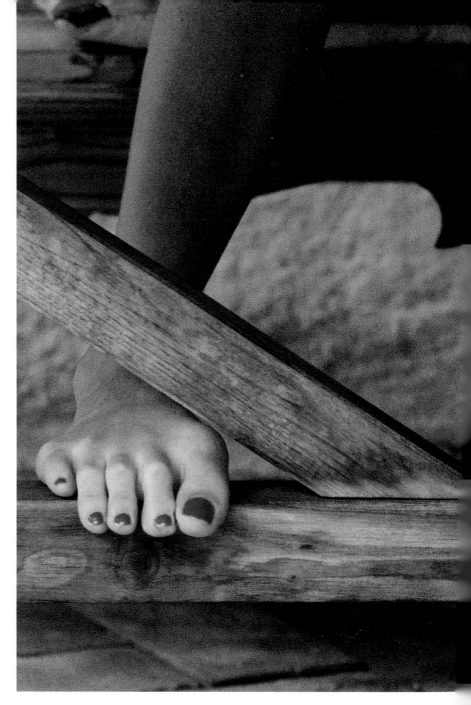

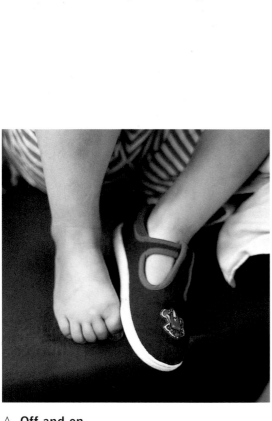

# feet first

△ **Off and on**

It is best to look out for interesting shots of feet, rather than trying to force things artificially. This child thought nothing of going round the house with one foot clad, whilst the other was bare.

As any parent who has had to buy children's shoes will know, feet are a powerful indicator of just how fast children grow up. At birth, the toes are almost microscopic, but by the time they become teenagers they already have fully-formed adult-sized feet. Understandably, therefore, they grow

out of shoes at a phenomenal – and expensive – rate.

Children's feet might not be the most obvious subject for a photographic close-up, but the results can be appealing. Bare feet can produce interesting studies on their own. The way they wear shoes can also produce

Other suggestions to try...

**Children's hands are another great subject for the close-up approach. Here are some of the ways you could photograph them:**

• Shoot a close-up of a baby's miniature hand cradled in the much larger, more worn hand of its father, mother or grandparent.

• Photograph a young child's fingers performing a intricate task, such as unwrapping a sweet.

amusing shots – it is not uncommon for children to put their shoes on the wrong feet, walk around with just one shoe, or insist on parading around in their parents' footwear.

An interesting idea for a picture is to juxtapose the size of a young child's footwear with that of his or her parents. Miniature red wellingtons, surrounded by giant black boots, for instance, would create an image that will remind you of just how small your children once were.

△ **Paint job**

The way people arrange their feet as they sit can sometimes produce interesting studies. Here the red of the painted girl's nails immediately grabs your attention, whilst the deliberately symmetrical composition stresses the pattern of the bench and table she is sitting at.

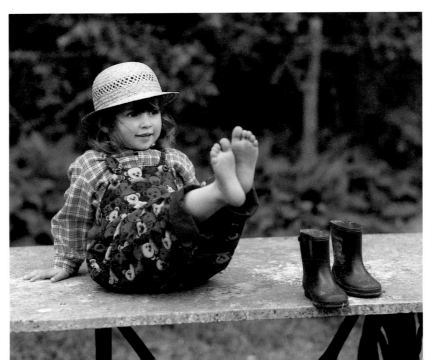

◁ **Show-off**

This little girl was keen to show off her new wellington boots, but once she had got everyone's attention she decided to parade her feet instead. It was a pose that was too good to miss.

A child's first bike, pedal car or skateboard marks a significant step on the road to independence. With their own form of transport and new skills, they present you with a wonderful series of photo opportunities.

# on the road

Adults remember their first car with great clarity for the whole of their lives. It is frequently the most expensive possession that they have bought up to that point, and something that they retain great affection for.

This motor vehicle, however, is very rarely the first mode of transport that a person takes control of. From an early age, children are usually given a succession of two-wheeled, three-wheeled and four-wheeled conveyances on which, and in which, to play.

Barely after some children learn to walk on their own two feet, they get given their own tricycle or push car. Such devices are not only excellent aids for learning coordination, but allow the

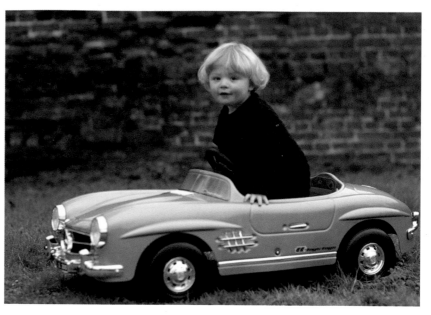

△ **Going for a spin**

When framing up side views of cars, bicycles, soapbox racers and so on, the photograph will look best if the composition leaves more space in front of the vehicle than behind.

toddler to indulge in countless hours of role-playing as they zoom up the hallway or through the back garden.

A year or two later, the child will then progress to a 'proper' bike, eventually abandoning the stabilizers and learning the fine balancing act needed to keep themselves pedalling on just two wheels. Along the way, children are increasingly given the opportunity to control other types of vehicles at fairgrounds and at theme parks. Then there are the more hair-raising forms of transport that follow, such as roller blades, scooters and skateboards.

All these forms of transport provide you with pictures that will bring back strong memories for the children in years to come – and will, as the children grow up, give you faster and faster subjects to practise your action photography skills on.

## Useful tip...

• With an SLR, use a slow shutter speed of around 1/15sec and zoom the lens whilst firing the shutter, for an interesting shot of subjects facing towards the camera which suggests rapid movement.

▷ **Concentration**

You don't need to see the child's eyes to get a good picture. Here, the pose suggests total absorption in playing with a new toy. Using the gravel drive as a background helps to make the luxurious model car look even more real.

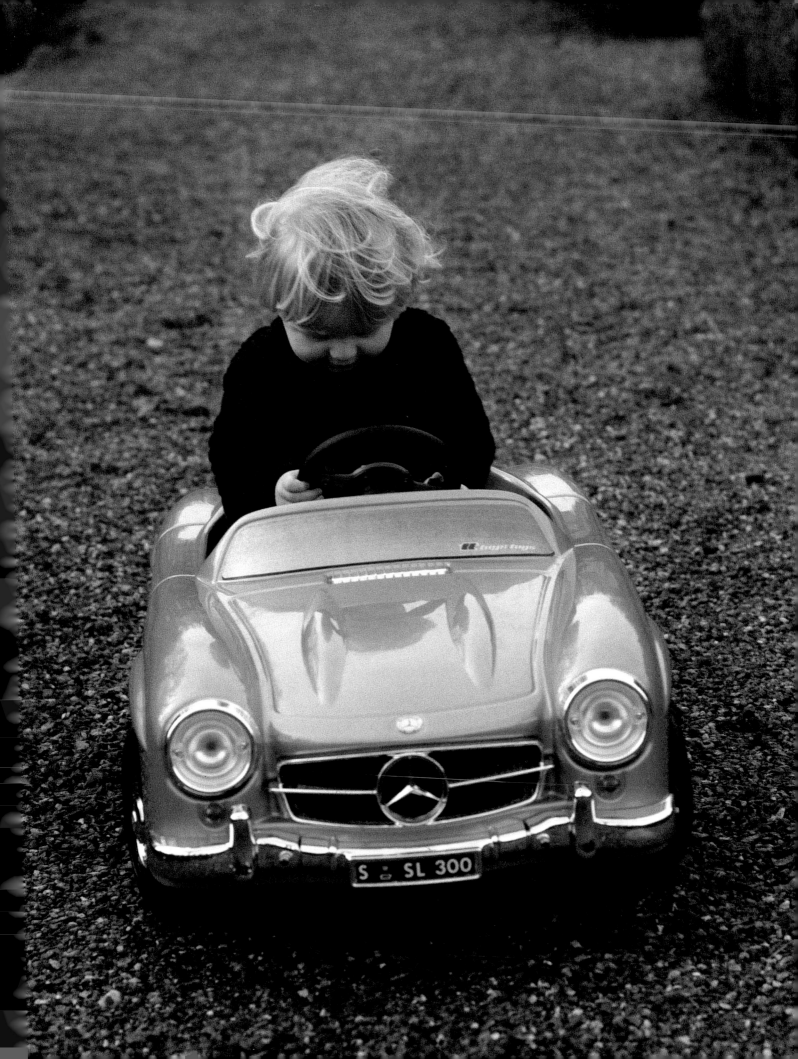

Ignore the advice from Hollywood; children and their animals are an essential combination to feature in your family photo album.

▽ **Bath time**

Giving the dog a bath provides the opportunity to shoot a lively sequence where all the participants are too busy to really notice the camera. When dogs get wet through bathing or swimming, always anticipate the point when they shake themselves dry over anything that happens to be in the way; use flash to freeze the water droplets on film.

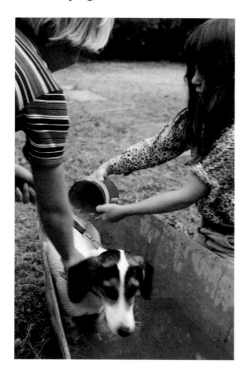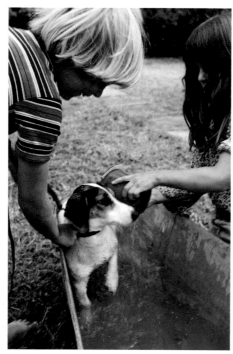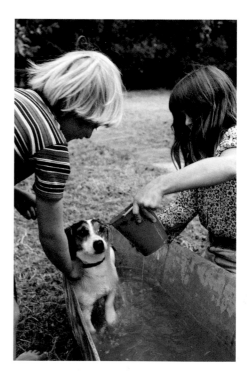

# pets

Useful tips...

• Pets often look their most striking when backlit, creating a halo around their fur.

• Let children use food treats to get the pets interested and looking the right way.

In the movies they advise you never to work with children and animals – but if you are going to photograph your whole family properly, having both troublesome subjects in front of your camera at the same time is going to be unavoidable.

For many people, the dog or cat is as much a member of the family as the children, and therefore is likely to take on more than a supporting role in your photographic archive. Other pets, such as rabbits, guinea pigs and gerbils, are considered educational playthings for the child. The youngsters have fun holding and watching their furry friends, and at the same time learn a bit about other creatures and how to look after them.

Children not only relate strongly to animals, but pets can also have different relationships with kids than they would have with other human beings. They will often put up with the maulings of an over-affectionate keeper much more readily than they would with an adult.

Getting both child and pet to look perfect in a picture together is often impossible, so it is best to look out for the pictures that develop in front of you.

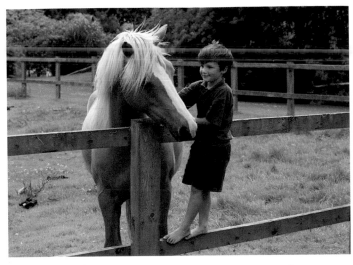

△ **A question of scale**

With large animals, such as horses and some dogs, it is rewarding to try and show the relative size of the child and the pet. Here, the boy needs to stand on the fence to be able to stroke the pony's neck – this will give the family a good idea about the child's height at the time, when they look at this photograph in years to come.

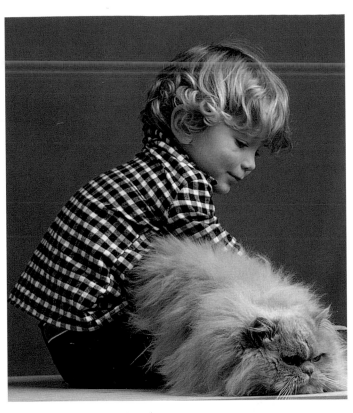

△ **Comic capers**

If the pet looks great, the child starts to cry, whilst if the youngster is all set for the picture, the animal tries to run off. Here, things have not gone quite according to plan, but I have instead caught a more amusing picture showing the cat's bid for freedom.

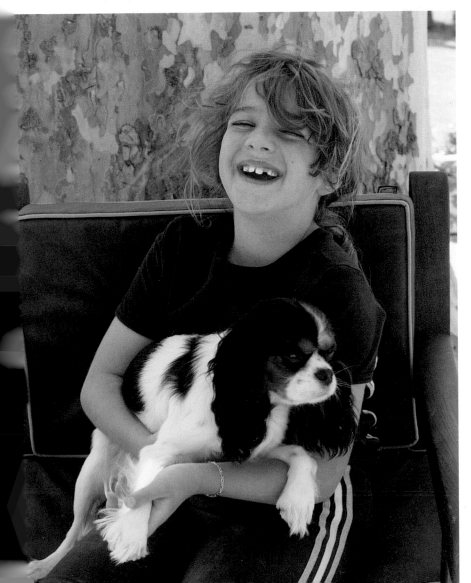

◁ **Happy face**

The young girl struggles to keep the spaniel under control, but in the process she breaks out into fits of laughter. The dog, meanwhile, does not look amused. A great moment in time caught by continuing to take pictures, even though the shot was less than perfect.

▷ **Going for a walk**

Who is taking who for the walk? It is unclear in the picture who has the upper hand. The strong diagonal lines created by the stretched dog leashes create a dynamic composition, which adds to the drama of the story that the image tells.

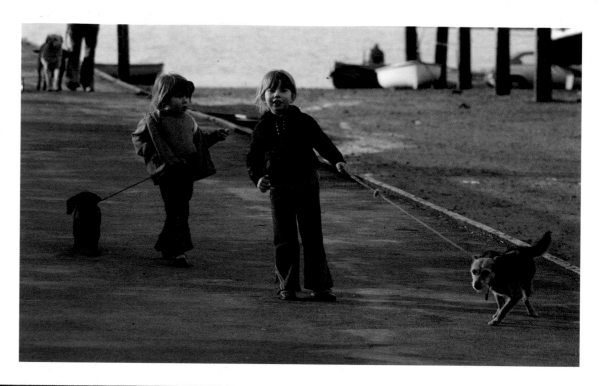

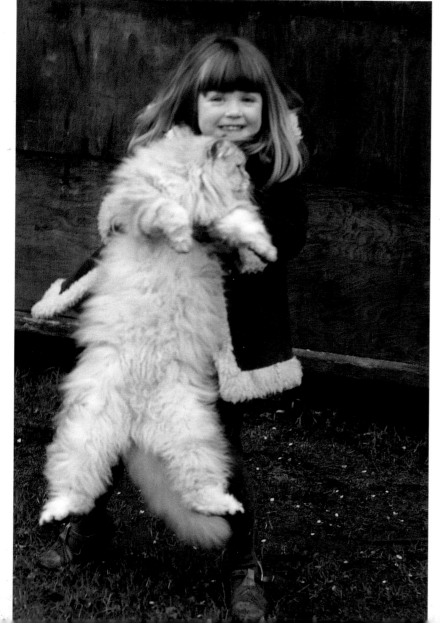

A child, for instance, will often hold up a pet to pose with in front of the camera. The child looks over-burdened and the pet looks uncomfortable – but the scene still makes a charming, and all too typical, portrait of childhood.

Look for more natural poses too, as the child plays with their pet, takes the dog for a walk, or sits stroking the family cat. Such candid shots allow you to sit and watch your subjects, choosing a moment when the composition looks either attractive or amusing.

◁ **Furry friend**

This cat is so large that it not only is almost as big as the girl, but it also seems that the feline friend has become an integral part of her coat.

▷ **Of slugs and toads**

The best way of emphasizing small animals, and to maximize the shock value of a child holding a frog or a big spider, is to use a wideangle lens setting. The hand and creature then both appear larger than life, if they are nearer to the camera than the child.

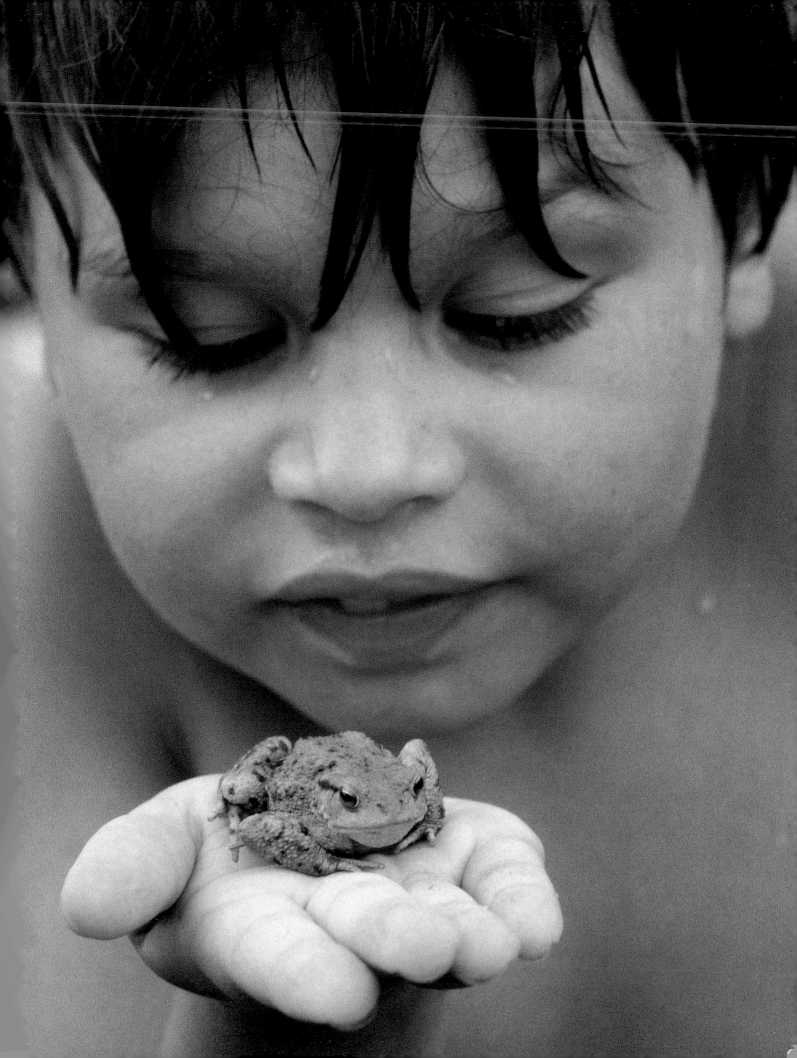

## ▷ From the horse's mouth

Although farm animals are generally friendly, you must still be aware of the dangers. Here, the young girl is safe in the arms of her mother from the powerful horse, but is still taken aback by the snorting animal.

## ▽ Natural bond

A wideangle lens and loose framing combine to show the whole Romanian farmyard, as well as the boy carrying a favourite black-eyed lamb.

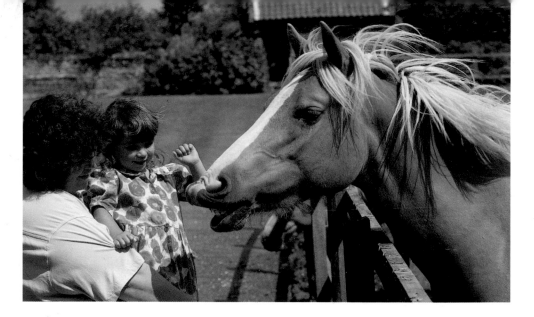

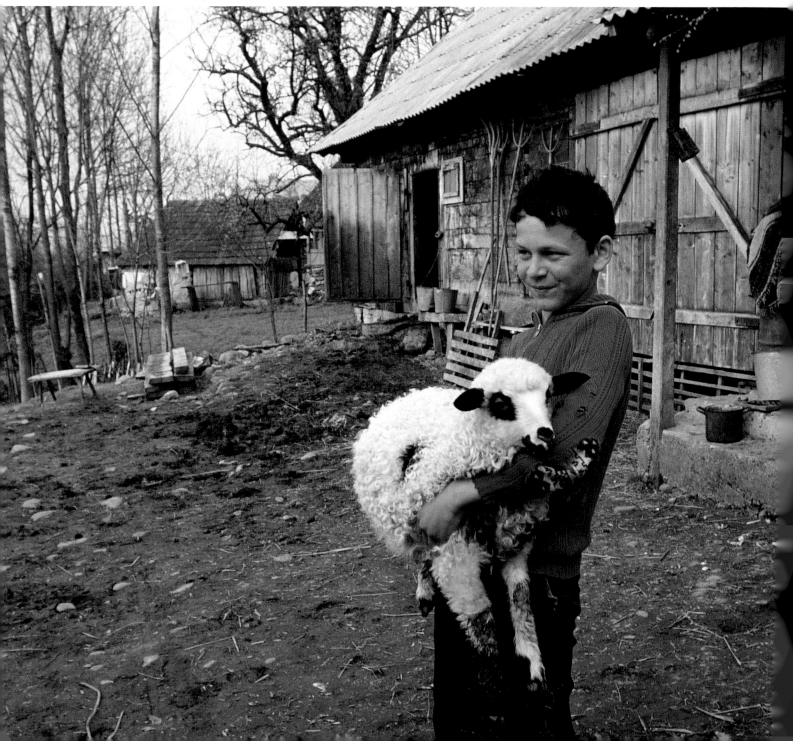

Special farms and modern-thinking zoos allow children to have close encounters with creatures great and small.

# on the farm

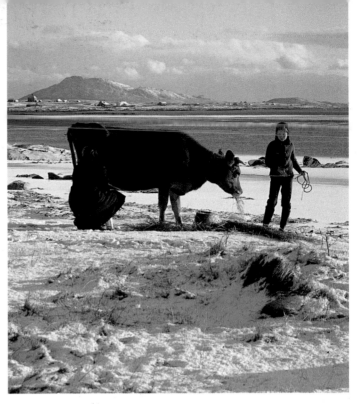

△ **A way of life**

The sight of a woman milking a cow by the sea whilst surrounded by a blanket of snow, creates a surreal scene. However, for the Scottish crofting family in the picture, this image would provide a stark reminder of life on a remote Hebridean island.

As well as pets, children are captivated by animals of all shapes and sizes. Whether on a visit to a zoo, or on a drive through the countryside, youngsters will be excited about seeing mammals that they may well have previously only seen in books and on television. But as far as child photography is concerned, the best places for capturing images of these encounters are at the increasing number of places that allow you to get a hands-on experience of animals.

More and more farms are now opening their doors to the public, not only allowing children to see cows, goats, sheep and so on up close, but also providing families with a chance to touch these domesticated creatures. You don't even have to venture into the countryside to do this – city farms and pet corners can be found that offer the same opportunities within an urban environment. Nowadays, even zoos frequently have sessions where youngsters can get in and stroke more

exotic species, such as llamas, lemurs and even tarantulas.

With any of these opportunities, it is a matter of positioning yourself so that you can see the animal clearly and it is identifiable in the picture, as well as being able to see the facial expressions of the children. In most situations, the best approach is to use a wideangle lens setting and then get in as close as the composition will allow – and choosing a camera position, if possible, that avoids unnecessary clutter in the background.

Of course, some children grow up on farms, and here the family business should form a frequent backdrop for your pictures. The children in these instances will have particularly close bonds with particular animals, and these should be shown in your pictures.

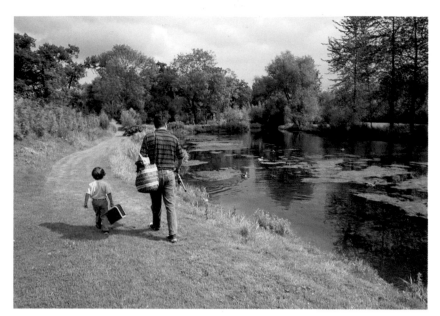

△ **Setting the scene**

A wideangle shot provides the introduction to the photo story. It shows the lakeside location clearly, and introduces the two main characters – the father and son.

Although a picture is worth a thousand words, there are times when you can't tell the story with one photograph alone. A sequence of shots is what you need...

# gone fishing

Whilst one good photograph can so often capture the memory of a day, there are times when a single shot is not enough. To show the full story, you sometimes need to show a sequence of pictures. Displayed together, a group of pictures can tell you far more about how a child coped with a new activity, or what they did on a particular day out.

Obviously, you will undoubtedly need to shoot more pictures than you will

actually need for the picture story, particularly because you are shooting real life, not a drama. You won't definitely know what is going to happen next. For this sequence of a young boy on a fishing trip with his father, I had hoped that the final picture would be one of him posing with his catch. Unfortunately, the fish got away, and the adventure story I was shooting turned into a photo tragedy!

▷ **All of a quiver**

To tell a story effectively, you have to capture a telling expression on the child's face. Here, we can see the child's excitement as he realizes that he's got a bite on the line.

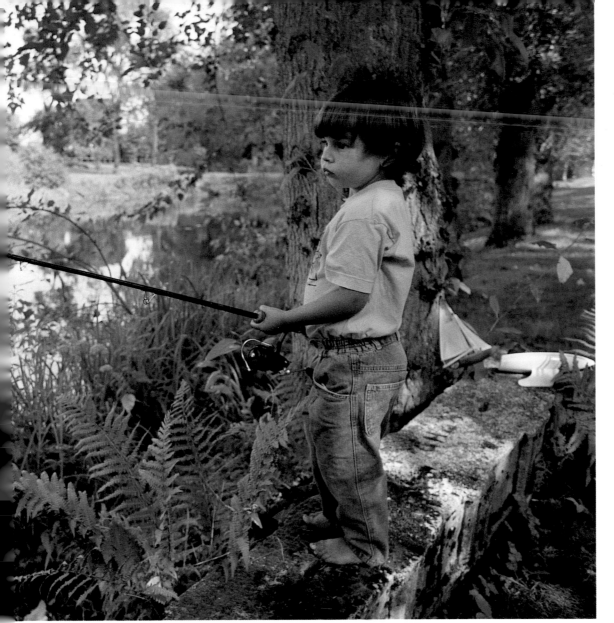

◁ **Cast off**

The main part of any fishing trip is standing around as you wait for something to happen. Such times give you a great opportunity to grab pictures of the child deep in thought.

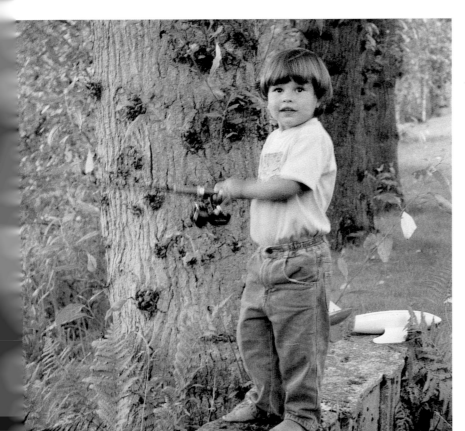

△ **The one that got away**

The concluding picture in the sequence says it all – the fish has got off the hook this time, and the little boy is left distraught. So close, but yet so far!

Use soft lighting to capture the many rainbow-coloured designs that can be created with face paints.

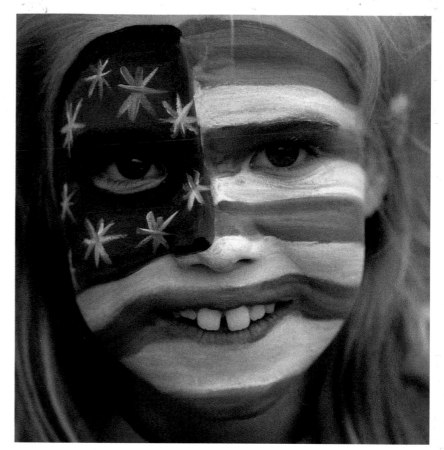

△ **Stars in her eyes**

By photographing the close-up of the painted face using indirect sunlight, you avoid strong shadows interfering with the artistic design. The bright colours of the paint, furthermore, do not need to be made even richer with direct sunlight.

△ **Work in progress**

The face-painting process can make for an interesting sequence, showing in half a dozen pictures, say, the child being given the facial features of a tiger.

# funny faces

Children no longer have to wait for their first appearance in a school play to experience the smell of greasepaint. Face-painting has become a popular amusement for children at fetes, parties and at holiday camps. With a few minutes work from an artistic volunteer, the face of the child is transformed into that of a lion, butterfly, princess, clown, or one of a thousand other designs.

On the face of a child, however, these brightly-coloured designs rarely last long before they begin to smudge and run. So to provide a lasting memory, you need to capture the finished effect on film before it is too late. To avoid problems with shadows, it is best to take these close-up shots out of direct sunlight, using a shady spot or a passing cloud to provide a softer light source.

▷ **Animal behaviour**

As with masks, children will often adopt the facial expressions, behaviour and sounds of the creature or person that they have been painted as. This role-playing will help you create a stronger picture.

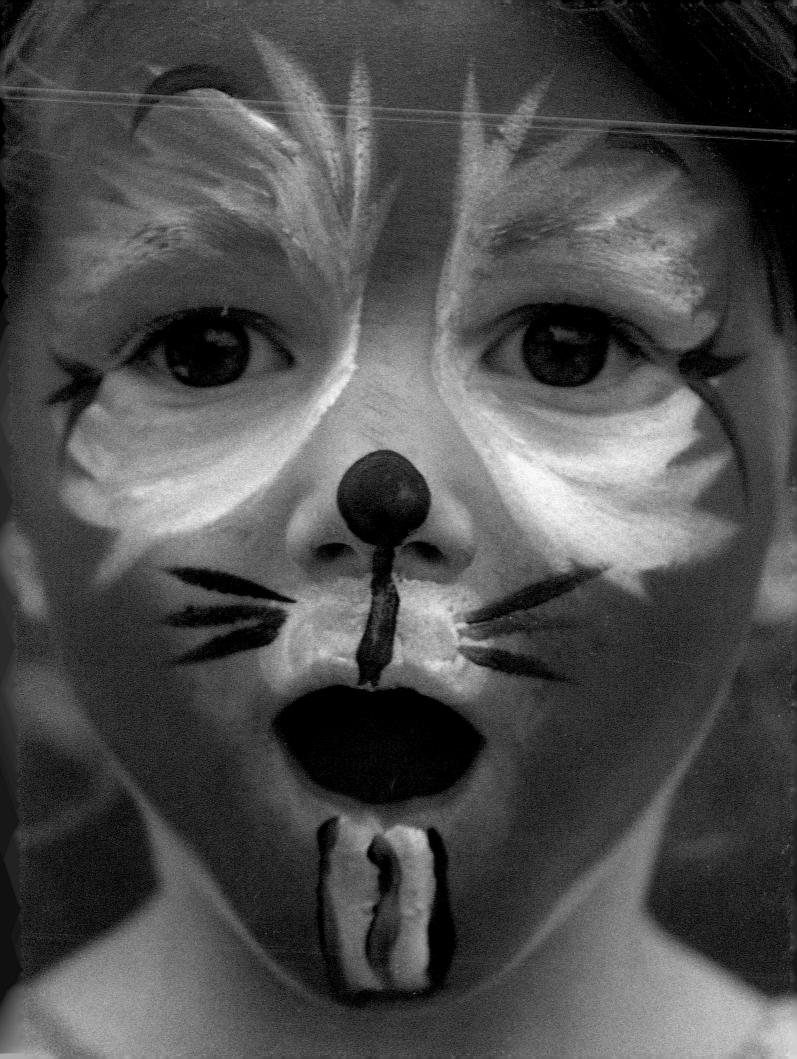

From toddlers to teenagers, the local park provides you a great opportunity for shooting action pictures of your children. And you don't need to resort to high shutter speeds in order to create a lively image.

# in the playground

△ **Climb every mountain**

Children can't resist climbing things – even out of the playground. This modern statue might not have been designed to entertain little boys, but it was sturdy enough for no harm to be done.

Playgrounds are probably one of the best places for photographing children. At any age, most children will jump at the chance of a trip to the swings or the climbing frame – and in most places you rarely have more than a short journey to find one. The range of equipment provided usually provides enough to keep kids of all ages the chance to have fun, show off, and be noisy without too many worries for parents about them making too much noise, breaking things or hurting themselves.

Despite the fact that many of the pictures that you would take at playgrounds will be of action subjects, this does not necessarily mean that you need a high shutter speed to capture what is

▷ **Slowing down**

At the bottom of the slide, the children start to decelerate. This makes an ideal moment to take your picture, particularly if you are using a compact camera or the light is not bright enough for fast shutter speeds.

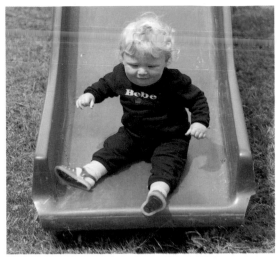

## Useful tips...

• For a dramatic shot of a playground roundabout, get on the ride yourself, and shoot the child using a slow shutter speed as the thing rotates. The background will be blurred, but the child will appear sharp. Use a shutter speed of about ⅟₁₅sec, and keep the camera as steady as possible – even though you will be dizzy!

• Turn your flash on to freeze the movement of a swing, see-saw or roundabout (see pages 40–41).

going on sharply. In fact, you can actually shoot pictures of children when they are perfectly still, but nonetheless end up with a lively image.

On the swings, for instance, the seat is always at a standstill when it is at its highest position in the swing. If you therefore shoot your pictures at the point at which the swing has stopped moving backwards, and has yet to begin moving forwards, you can make do with an ordinary shutter speed. This technique is particularly useful when using a compact, where you have no direct control over the shutter speed.

Similarly, on the slide the child will be moving more slowly at the top of the slide than at the bottom of the slope, and will then slow down on the flat section at the end.

If you photograph your child at these split moments in time, it is easier to get a sharper image than if you shoot when the child is moving at full speed. There are similar moments in many sports that you may photograph – a golfer's driver is momentarily stationary, for example, when at the top of the swing.

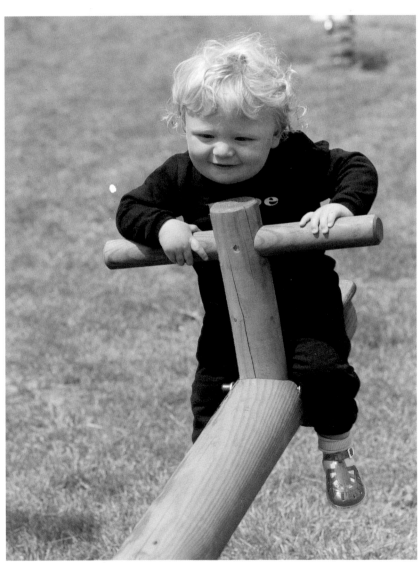

△ **Peak of the action**

For a split second at least, the see-saw stops moving when one of the seats is at its highest and the other is at its lowest. At this moment, just as the direction changes, you do not need a high shutter speed to arrest the action, and at the same time the angle of the see-saw is also at its most dramatic.

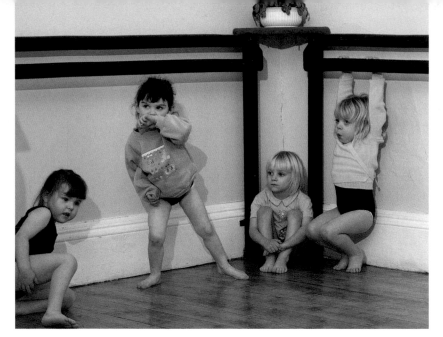

◁ **Limbering up**

The young ballerinas wait for their turn, as the teacher individually shows each member of the class how to do a particular step. The various positions they have adopted as they look on is more reminiscent of wrestlers warming up for a bout, making a rather amusing study in human anatomy.

Super-fast film can be a great saviour when shooting fast-moving indoor activities, such as ballet classes.

# the dance lesson

△ **A giant leap**

As the dancers get older and more proficient, their steps become more acrobatic. This girl was practising her jeté, and I tried to time my shot to ensure that her balletic leap appeared as high as possible in my photograph.

Watching a ballet lesson can be an amazing experience. It is not just the artistry of the steps that impresses, it is the sheer discipline that the teacher brings to the class. An unruly mob assembles at the beginning of the session, but with a couple of words the ensemble becomes like a platoon, following the words of their sergeant with military exactness and in silence.

Getting to see this for yourself is not easy, even if you are paying for the lessons. Most teachers insist on conducting lessons without prying parent eyes to distract the children. Instead, mothers and fathers are usually given grand shows or end-of-term sessions where they see the progress of their daughters (boys are a rare sight).

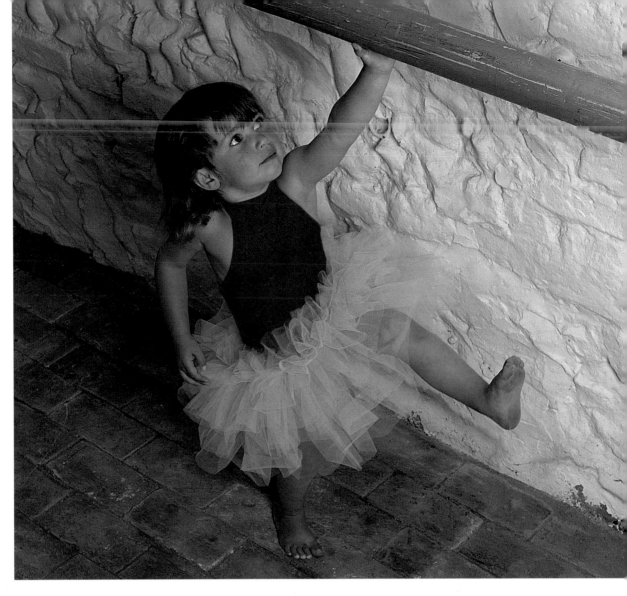

### ▷ Barre work

This pretty girl in her tutu was desperate to try and reach the barre with her foot, imitating the exercise of older students. Unfortunately, she was a good way short, and I emphasized this by shooting from a high camera position.

## Useful tips…

• Pay as much attention to those on the sidelines as to those performing.

• Focusing can be tricky in lowlight. Pre-focus on a point where the dancers will pass through (see page 84).

But if you can talk your way into a real class, you can get brilliant pictures.

A major problem to contend with is the light level. It is not usually bright enough in these halls to take shots of moving subjects. You could use flash, but this can be distracting for the dancers. And unless you have a powerful enough bounce flash system, direct flash destroys the ambience of the scene.

The solution is to use a very fast film, with a speed of ISO 1000 or more. The grain this adds to the pictures suits the subject well. You could use fast black-and-white film; this will also avoid the strange colours that the strip lighting often found in such halls can create.

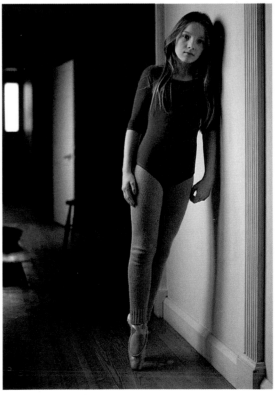

### ▷ On tip toes

It takes years for ballet dancers to progress to wearing block ballet shoes, allowing them to walk gracefully balanced on the tips of their toes. These shoes are therefore a status symbol amongst young dancers. I like this shot because this girl still continues to stand 'on pointe' even when out of class. The pose is emphasized by the strong vertical lines running along the corridor.

▷ **Measuring gauge**

I love this fun photograph of girls showing off their skills before a class. Their bodies add to the pattern of the bars themselves. It is almost like a bar graph showing the varied heights of the children.

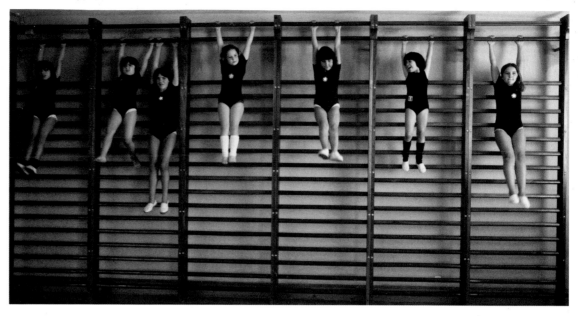

# When shooting gymnastics, don't chase the action, wait for it to come into your sights – and then fire!

# hanging around

Olga Korbut, Mary Lou Retton, Nadia Comaneci – even the greatest gymnasts were little more than children when they were at their peak of their prowess. They start much, much younger, of course, and the vaults and exercises can look very impressive in photographs long before they reach Olympic level.

As taking pictures goes, gymnastics is probably an easier subject to tackle than ballet, even though many of the problems are the same. The great beauty of gymnastics is that the passage of the performers is generally defined by the piece of apparatus they are using at the time. A gymnast on the beam, for instance, has only a 10cm piece of wood to stand on, for instance – and even

with the floor exercises the most spectacular movements are along a line running diagonally between the corners.

These physical limitations mean that you can use a trick often used by sports photographers, known as pre-focusing. Rather than trying desperately to make your camera focus on a fast-moving target, you instead use manual focus or the focus lock to focus on a point which you know the gymnast will pass through. You then press the shutter at the moment the person reaches this point.

▷ **Circle of light**

When photographing this rhythmic gymnast, I noticed a bright pool of light reflecting off the centre of the floor. I waited for the girl to enter this spotlight, using it as a backlight to emphasize the shape of her and her hoop.

### Useful tip…

• If you photograph the gymnasts as they head towards the camera, rather than moving across the frame, you don't need such a fast shutter speed.

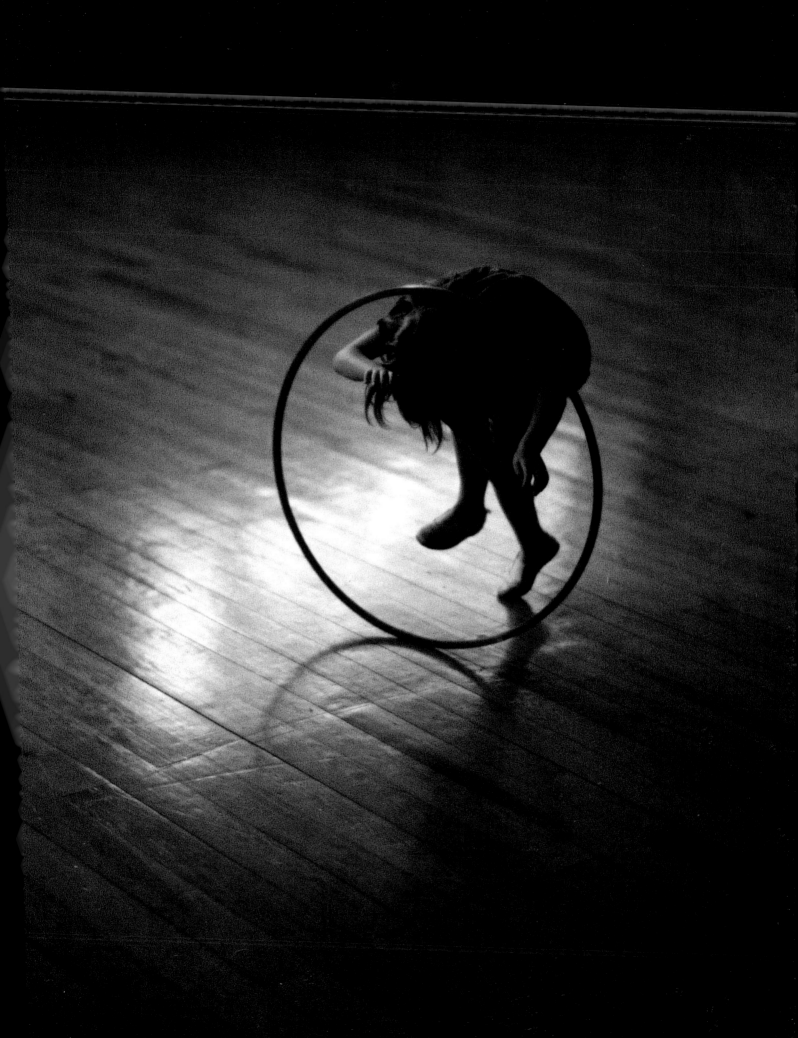

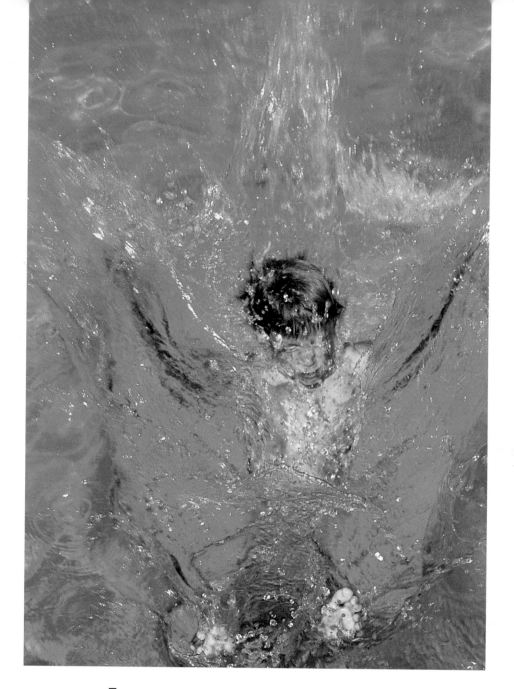

As long as you can keep your camera equipment dry, swimming makes a great action subject for the camera, particularly if you can use an outdoor pool for your shots.

# at the swimming pool

One of the great advantages of swimming, compared to so many other sports, is that, although it is often an indoor sport, it can also be done outside.

As far as the photographer is concerned, the outdoor pool is far more preferable to the enclosed one. Not only do you get far better light, but the colour of the water is also a much more alluring shade of blue. This makes a brilliant backdrop for your pictures – whether action shots showing the increasingly competent swimming style

## ◁ Big splash

To photograph this boy jumping into the water, I stood on a diving board, so that I could be directly above him. I prefocused the lens on the spot where I reckoned that he would hit the water. With the lad's cooperation, I took a practice shot to ensure that I had the shot framed up correctly, before taking the final frame. As so often with such things, the first shot was actually better than the second!

## Photographing around water...

**Cameras do not like getting wet, but there are precautions you can take:**

- Keep a towel or cloth with you so that you can wipe off any splashes immediately.

- If your camera gets really wet, use a hair-drier to dry it straight away.

- Shoot your pictures through a clear plastic bag, to give yourself more protection.

- To take a camera into the water, or by salt water, read the tips on page 92.

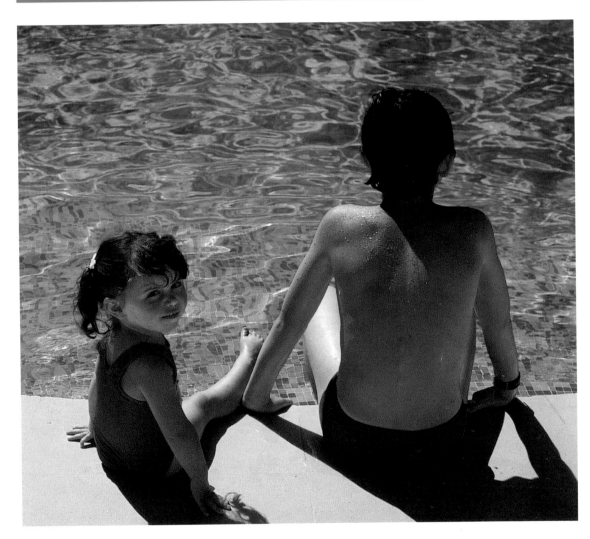

## ▷ Water baby

Swimming is one of the many skills that children normally learn in the first few years of life. This girl looks justifiably proud as she sits next to her brother, having just completed her first width without armbands.

of your youngsters, or just shots of the kids mucking about in the water.

On a summer holiday, with sunny conditions you will be able to choose from a wide range of shutter speeds. Choose one of the fastest available – $^1/_{1000}$ sec or faster – as this will freeze the individual droplets of water as the youngsters splash around in the pool.

## ◁ Frog face

The goggles that people wear for swimming or for snorkelling give a sinister look to the face. Here, the red diving mask gives a sinister overtone to this close-up portrait.

# action!

Most people think of long telephoto lenses as essential for sports photography. Although they are necessary for some sports, you can make do with more modest lenses and still take good action shots.

The bread-and-butter lens of the professional sports photographer is the 300mm, a long telephoto which is equally at home at taking close-ups of tennis stars' faces as it is at taking shots of sliding tackles on the other side of the football pitch. For the SLR user, such focal lengths can be found on a variety of different zooms, such as a 70–300mm, which covers practically every telephoto setting that you will ever need.

Not everyone has this lens range, though, particularly if you use a compact. But this does not mean you cannot get good action shots. The focal

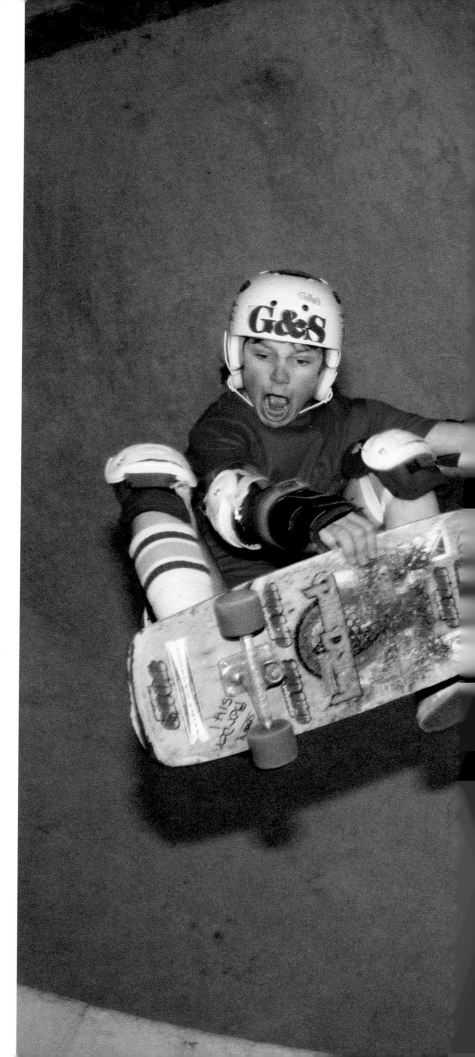

▷ **Suspended in the air**

To capture this skateboarder sharply, I used a Vivitar 283 flashgun set to automatic on my Pentax SLR. This provided a burst of flash lasting just 1/30,000sec, freezing the boy in mid-air. I used a wideangle lens, and took advantage of the lad's skill, to ensure I was in just the right position as he turned at the top of the ramp.

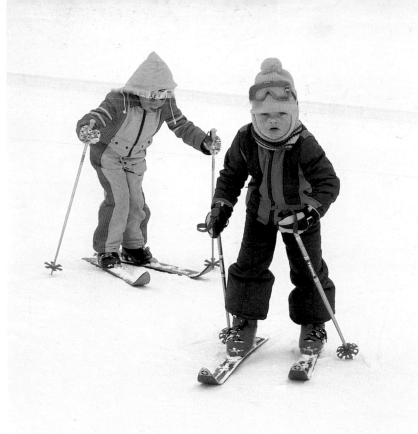

◁ **Slippery slope**

Pictures of the first outing on the piste will be particularly meaningful for the child in later years, should he or she become a keen skier. The clumsy stance will then look even more amusing. When taking pictures in snow, be aware that the huge expanse of white background can throw out the exposure. If you can, lock the exposure to that for a close-up of the face. Alternatively, give the shot slightly more exposure than usual, so that the snow looks white, rather than a muddy grey.

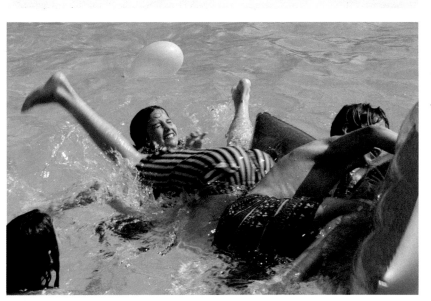

◁ **Rapid sequence**

When taking shots of teenagers playing about in a pool, you have no time for composition – you just need to take as many pictures as you can in quick succession. If your camera has a motorwind setting, use this to help you get an action-filled sequence.

length required depends on how close you can get to the action. Some sports, such as skateboarding, can be shot from so close in that a wideangle is perfectly adequate. Even with field sports such as baseball and soccer, you might be confined to distant sidelines in serious games, but with the kids you can get on the pitch and amongst the action, in search of frame-filling pictures.

The younger the child is, the safer it usually is to get into the fray in this way – however, you must use your own judgement, and be prepared to move quickly, to avoid risking injuring the children, yourself or your camera.

Sun, surf and sand – beaches have all the elements to keep the children happy. This gives you plenty of time to experiment as you shoot photographs of them having such fun.

# by the sea

The beach and the seaside are the classic symbols of both summer and holidays. But for children, they represent far more than a place to relax under the sun. The beach is the perfect playground – there is plenty of space, and plenty to do.

There are none of the usual confines the child finds at home; they can dig holes and no one is going to get cross; they can splash around with the water, and they can do no harm; and they can roll around without any fear of being told off for getting their clothes dirty. Understandably, even without taking into consideration the other photographic merits of the seaside, this is a perfect place to take pictures of the children – simply because the children will undoubtedly be at their most relaxed and at their most natural.

As the children will be occupied, you will be able to take pictures of them without them becoming self-conscious.

### ◁ Sun worshipper

Teenagers may well not want to build sandcastles, but they may be happy to lie on the sand or sit by the lido all day, soaking up the sun, showing off their tans, and eyeing up members of the opposite sex. Don't forget to include such shots in the family album.

### ▷ Jumping the waves

Children love jumping over the breaking waves at the shoreline. A picture of such a leap can capture the whole spirit of youth – the sense of adventure and freedom, worry-free pleasure. To shoot such pictures you will really need to get your costume on and put up with getting a bit wet yourself, although you'll need to ensure your camera is kept dry at the time.

### ▽ Keep it loose

Don't always try and fill the frame with your subject. In this shot, I have deliberately left acres of space around the boy. The relatively small size of the child at the side of the picture is then contrasted against the enormity of the ocean in front of him.

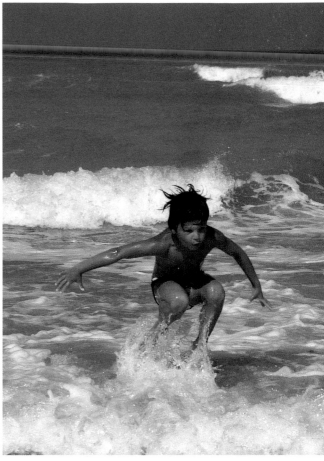

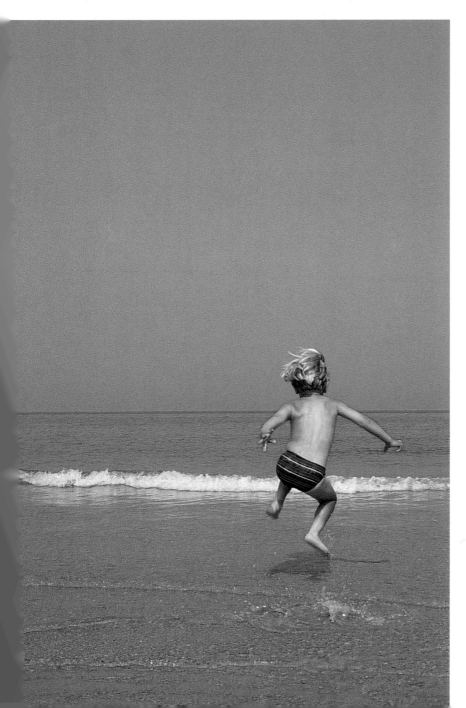

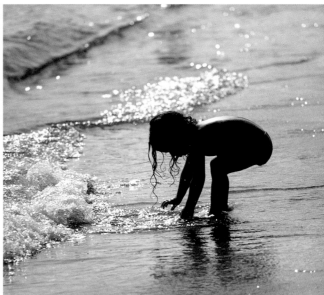

### △ Shooting into a setting sun

Towards the end of the day, it is worth shooting backlit shots at the sea's edge. The sun sparkles on the surface of the water, creating an attractive background, whilst bathers in the foreground are turned into bold shapes.

▽ **Splash of colour**

Look out for how the colours of children's toys can help give that extra something to your pictures. A red bucket, for instance, may attract attention, or a net might lead your eye across the picture from the child to the rockpool. Here, a rainbow-coloured kite creates a dramatic focal point to the shot of the boy striding up the shoreline.

▷ **Shell shocked**

Rock pools are another attraction of the seashore – children will love exploring them to see what aquatic wildlife they can find. Not everyone will be impressed, however, as this shot goes to show.

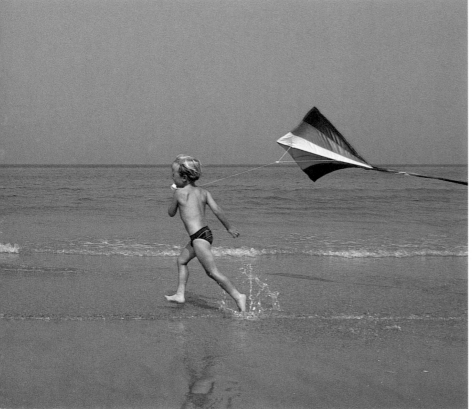

Whether they are building sandcastles, leaping the waves, playing with a ball or searching for shells, many of your pictures will be full of life, purely by recording them.

Not every shot, however, has to be dramatic or energetic – the surroundings will also allow you to capture quieter moments of contemplation as they sit soaking up the sun, or watch others along the shoreline. These more relaxed shots will act as a contrast to the more action-packed frames on your beach film.

## Keeping the sand and water out...

**Although cameras can survive the odd splash of pool water (see page 86), you have to be far more careful around salt and sand. Here are some ideas:**

- Salt water is corrosive to metal, whilst abrasive sand can scratch film and damage delicate mechanisms.

- Special housings and casings can be bought for most cameras to protect them in these situations.

- Weatherproof casings offer basic protection, but save worries on the beach.

- Fully-waterproof housings can even be used underwater. Also, consider the waterproof 'disposable' cameras which can be bought for use in the waves.

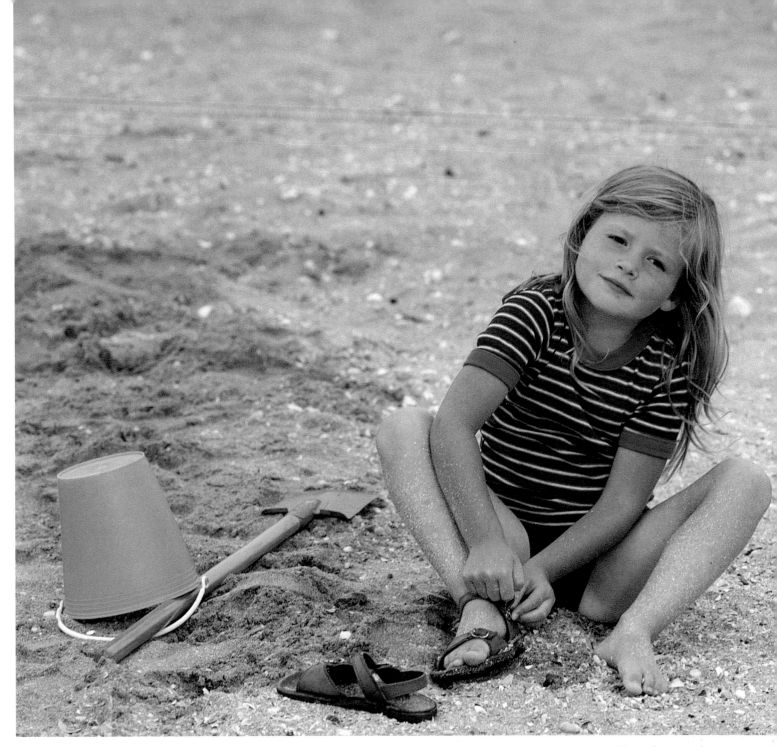

△ **Gleaming sand**

A beach is a lovely place to take portraits, even when the sun is hidden by the clouds. The sand acts as a giant reflector, providing a flattering light that ensures the person is lit evenly all over, as in the shot above.

The beach not only provides an opportunity to shoot a wide range of activities; you will also have the time to try out poses and set-ups you have not had a chance to explore before. Inevitably, not all your pictures will be great ones, but you should accept that you learn by your mistakes. If the idea was a good one, but the results do not match your expectations, think of the pictures as helping you both to develop the idea further and to learn new skills.

Finally, don't show people all the pictures you take. Your immediate family may insist on seeing every frame, but with others be selective, only putting the better pictures in your album. They don't need to see all your 'practice' shots – everyone prefers to see a few good shots, rather than the whole mixed bag.

A bored child never makes a good photographic subject. If you can keep them distracted whilst in a pose, you can not only keep shooting longer, but the pictures will look more natural.

△ **Blowing bubbles**

For this shot I used a simple background, bought from a specialist photo dealer. A suitably-painted wall, or a curtain, would have done just as well. The dark background helps the bubbles stand out far better than they would against a lighter colour.

# keeping them occupied

## Useful tips...

- When using flash, a slow-speed (ISO 100) film is fine.

- Use the telephoto lens setting on your zoom. This helps keep the background out of focus.

- Get your backdrop and equipment completely ready before you call the child in.

- Children have a short attention span – be prepared and shoot quickly.

Instead of paying for the services of a professional portrait to take that extra-special portrait of your child, why not have a go at doing itself? You will save yourself a small fortune.

First, you need to prepare somewhere to be your makeshift 'studio'. Ideally this should be a long room that allows you to have plenty of space between you and the child, and plenty of space between the child and the background.

You can buy a range of backgrounds from specialist stores – a plain black roll of paper can often be the most impressive. More elaborate backdrops can be purchased, such as painted skies: these are not cheap, but still are much cheaper than getting someone

else to take the photographs for you. Alternatively you can use large lengths of material or a painted surface. You could even paint a wall especially for the session!

Once you are set up and ready to go, it is worth finding something for the child to do to keep them occupied whilst you shoot a series of poses, without over-complicating the picture. For the youngest children a balloon provides a great simple prop, whilst with older kids a bubbles are a proven winner.

▷ **Plain or patterned?**

Notice that the simple red top of the boy in this shot works much better than the patterned dress of the girl in the picture at the top of the page. Plain-coloured clothes often work best for any type of portrait.

Getting the children to deck themselves out in their favourite dressing-up clothes is another way to gain their cooperation during a formal indoor portrait session.

# acting the part

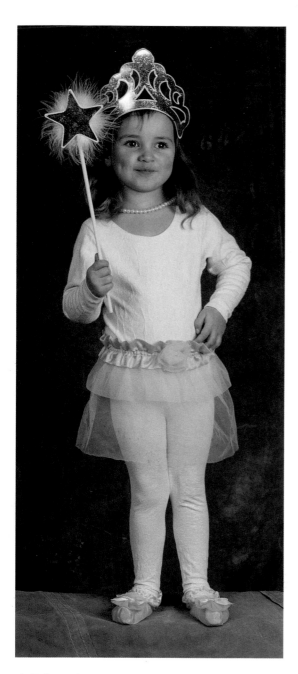

△ **Fairy princess**

For this picture, I used an old tarpaulin for a background in my impromptu studio. The battered sheet added extra texture and shading to the backdrop. The lighting was provided by flash, with fill-in from the windows of the converted conservatory on a cloudy day.

When shooting more formal pictures around the house, another way of getting the children to pose for longer is to get them to dress up. As Superman or Snow White, children will enter the spirit of the part, making the pictures look more dramatic, and helping them to get into the spirit of the shoot. Another crucial thing to watch when turning a room into an impromptu studio is the lighting. With a single on-camera flash it is hard to recreate the multi-lamp set-ups used by a pro.

Go for a room that has plenty of windows: a conservatory is ideal, as it will help light the background and fill in shadows cast by the flashgun.

Curtains and blinds can be used to control exactly how much light is coming through the windows, and what it is illuminating. Shadows can also be softened with large pieces of white card, white sheets or large mirrors, which will bounce light from a window into the darker areas of the frame.

▷ **Role-playing**

In fancy dress clothes, children can adopt the personality and behaviour of the person that they are trying to play. Here, the brother and sister adopted great poses for their hospital characters without any prompting from me.

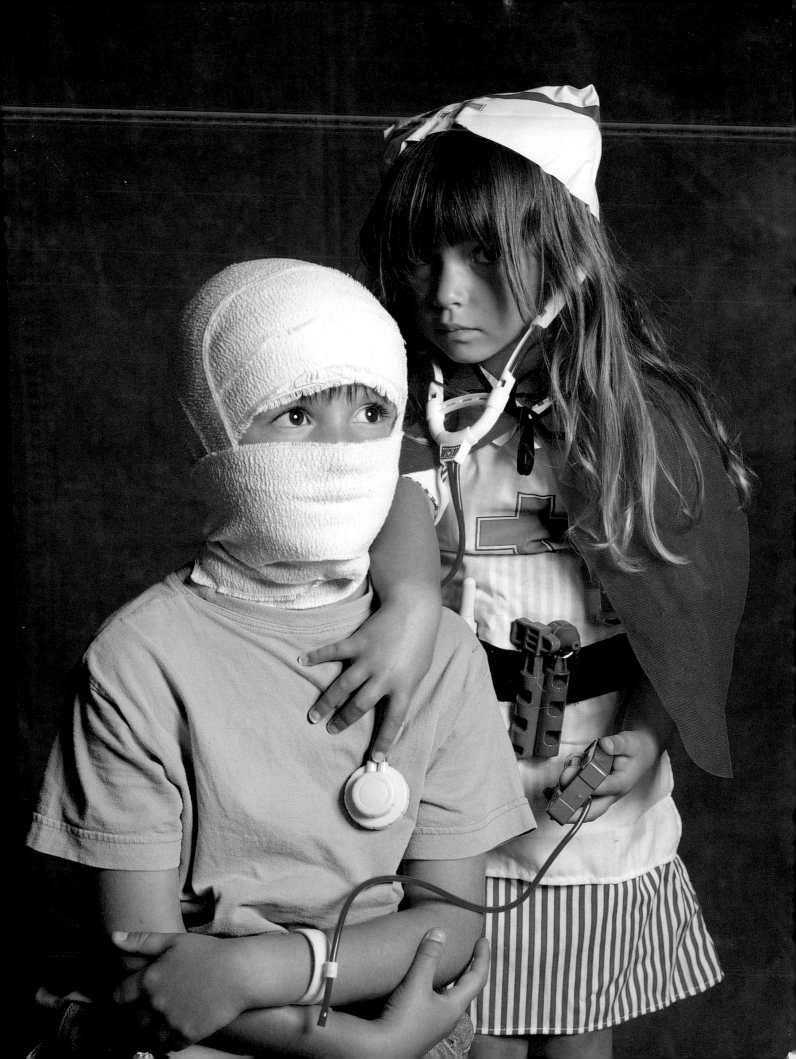

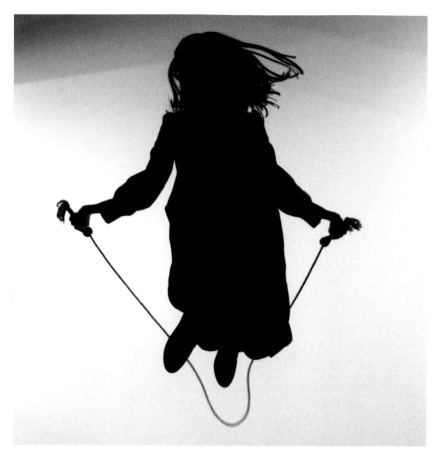

△ **Skipping**

You can't see this girl's face, but there's no mystery as to what she is doing. This picture would make a great decoration for a children's bedroom.

With creative lighting and a bit of thought, you can turn your children into dark cardboard cut-outs of themselves.

# silhouettes

### Useful tips…

• Keep the children as far away from the background as possible.

• If you use spotlights rather than flashguns, use black-and-white film, so as to avoid any problems with the lamps creating strange-looking colour casts.

• Expose for the background, not the foreground. Turn the camera's flash off.

One of the great advantages of setting up a makeshift studio in your own home is that you can keep on taking pictures when it is raining, or even when it is dark outside. A portrait session with the kids can be a great way of whiling away a wet winter afternoon – and it also gives you a chance to be more adventurous with your pictures.

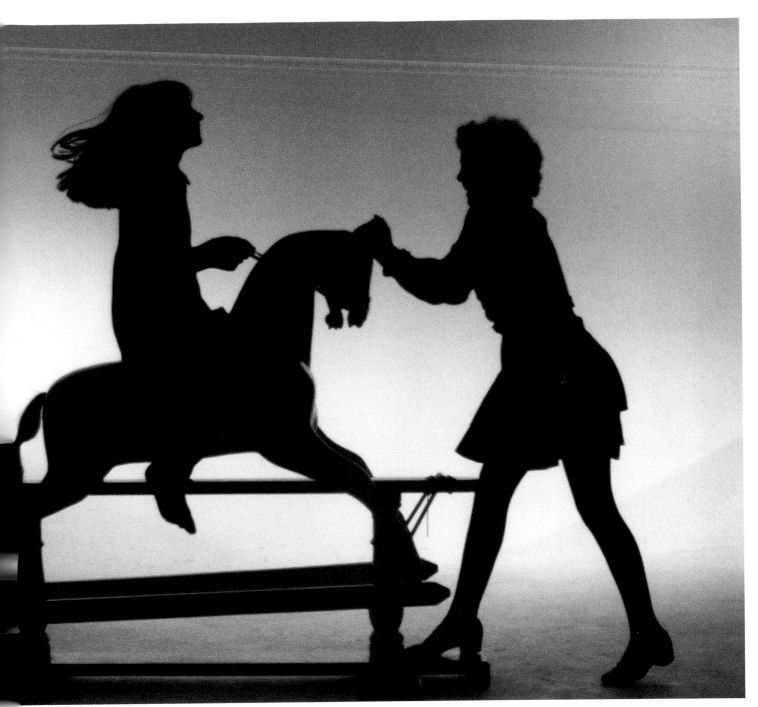

△ **Rocking horse**

The rocking horse provides a great centrepiece for this picture, creating natural, identifiable poses for the two girls. The shot, despite its simplicity, captures the spirit and timeless nature of childhood.

One idea is to try backlighting your subject. In Victorian times, it was popular to have silhouetted cut-outs made of yourself with black paper – it is amazing just how recognizable many people are from just seeing the outline of their profile.

You can recreate these kind of pictures with little more than a white wall and a couple of powerful lights. Rather than lighting the children, the lights just illuminate the background. If you judge the exposure right, the background is then shown white, whilst the children become dark silhouettes. You could easy embellish these pictures by including toys with familiar and easily recognizable shapes.

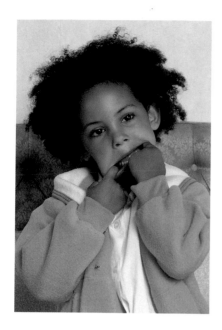

◁ **Wide-mouthed frog**

I shot this sequence of shots in a bedroom in the child's home, to help her feel relaxed. With a little prompting, she pulled a wide variety of faces at the camera, allowing me to shoot a whole roll of film without her getting fidgety.

▷ **Fish face**

By putting the camera on a tripod, I was able to keep eye contact with the child and talk to her as I shot. This technique also means that she is not looking directly at the camera in all the pictures.

Another way to make set-up portraits fun is to get your children to pull faces at the camera. This way you'll gain the kids' cooperation and avoid gloomy faces.

# silly expressions

## Useful tips...

• Use the telephoto setting of your zoom, if you have one.

• Help the kids get in the spirit of things by pulling faces at them as well!

• Dress the child in plain, bright-coloured clothes.

Most children hate having to hold staid, formal poses for minutes on end. Instead of using props or costumes to make an indoor portrait session, you could just get them to make funny faces.

You can guarantee that both toddlers and teenagers will love acting up to the camera in this way. If you encourage them to pull faces as they pose, it will help break down any shyness or reticence that they have. As they enjoy themselves, you will not only be able to capture some hilarious silly expressions, but as they pause for thought between poses, you will also be able to shoot natural smiles.

Shoot as many pictures as you can. Each will be different, and some will undoubtedly be more successful than others. You will be amazed at how many expressions are possible. The best of the selection might make an interesting collage which could be mounted together in a picture frame.

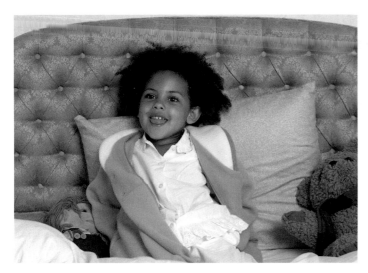

### △ Landscape format

Don't forget that you hold your camera two ways when shooting any subject – horizontally or vertically. Here, I used the landscape format, but this has the disadvantage of showing more of the bedroom clutter, and the child takes up less of the picture. The vertical portrait format, used for the other pictures on this page, works better.

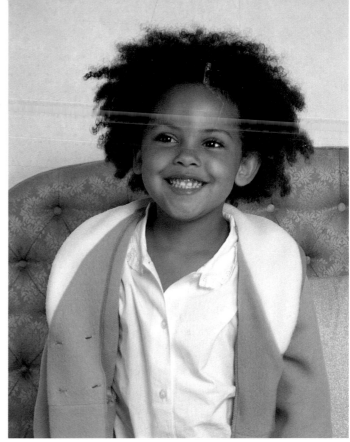

### △ Make them laugh

To keep the session going, you should join in the fun and pull faces too. But when you do this, remember to have your camera ready for action, as hopefully your antics will draw natural smiles from your subject.

### ▷ Pause for thought

The idea behind the 'funny faces' technique is that it will make the child relaxed. Whilst the girl pondered her next expression, I shot this delightful pose.

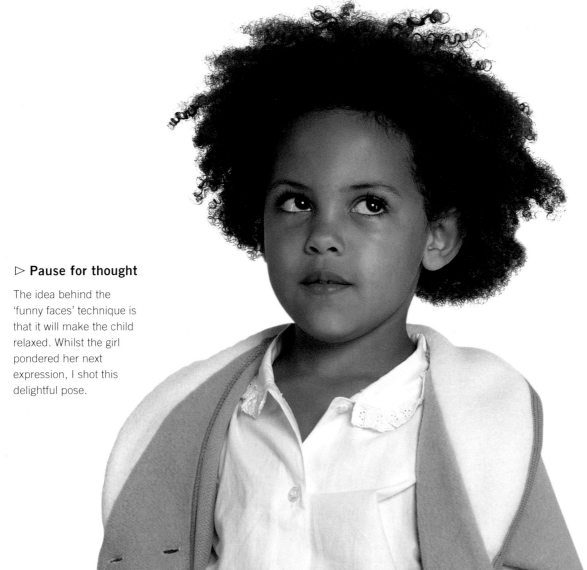

For indoor shots of children relaxing with their parents, try taking your pictures at bath time or story time.

◁ **Reflections**

Mirrors in bathrooms can provide an interesting way of framing your subject. Include the complete border of the mirror, and shoot from a diagonal angle that ensures that you and the camera are not in the shot.

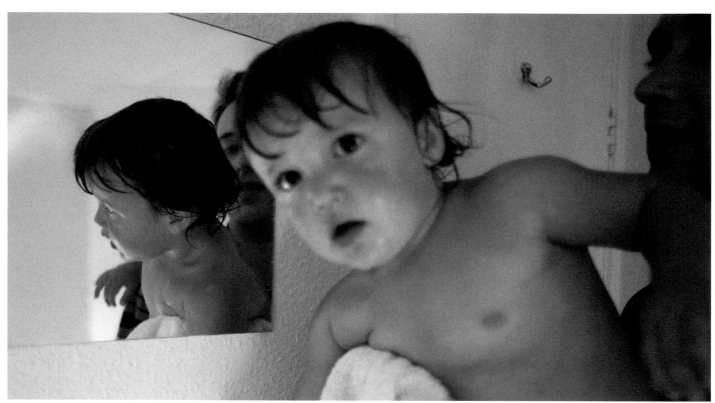

△ **Raising the child**

To avoid a background cluttered with sinks and other bathroom paraphernalia, I asked the father to lift the boy up. In this way, I was able to use the wall for the backdrop, cropping out everything in the room that was below waist level.

# time for bed

Whilst your home can be pressed into service as an informal studio, don't ignore the fact that it can also be used as a backdrop for more spontaneous pictures too. It is all too tempting to shoot most of your photographs out of doors, when the weather is fine, but by doing this you can miss many of the key moments of growing up.

For young children in particular, a bath before bed is a daily ritual in most households. From the earliest days, the foam and water are not just for cleaning mucky faces – they also help relax the child before sleep. Hopefully, bath time can also be an enjoyable few minutes for both child and parent. For working mothers or fathers, this part of the day

can also have a greater significance, being part of the often far too limited 'quality time' that they are able to have with their children.

Pictures of the children splashing around in the company of the closest members of the family, therefore, can make great shots for the album. As many bathrooms have little natural light, you will be reliant either on using fast film or flash. If you use the latter, try bouncing the flash off a white ceiling or wall, to soften the effect.

With the bath over, the next part of many children's going-to-bed routine is the story. This provides a restful time during which you can capture the facial expressions of the children, as they react to what is being read to them.

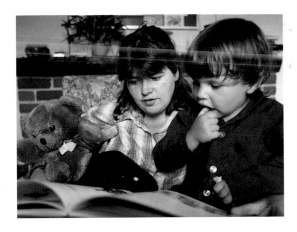

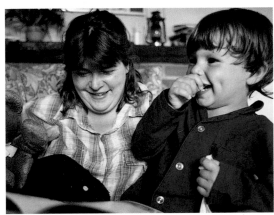

◁ ▽ **Storyteller**

A bedtime story allows you to capture the facial expressions of both the parent and the child side by side. Both are preoccupied by the book and the things that happen in the tale. This allows you the opportunity to shoot natural expressions and shared moments, without either of your subjects paying much attention to your presence. Pay attention to any typical tired behaviour from the child, such as sucking a thumb, cuddling a teddy or yawning.

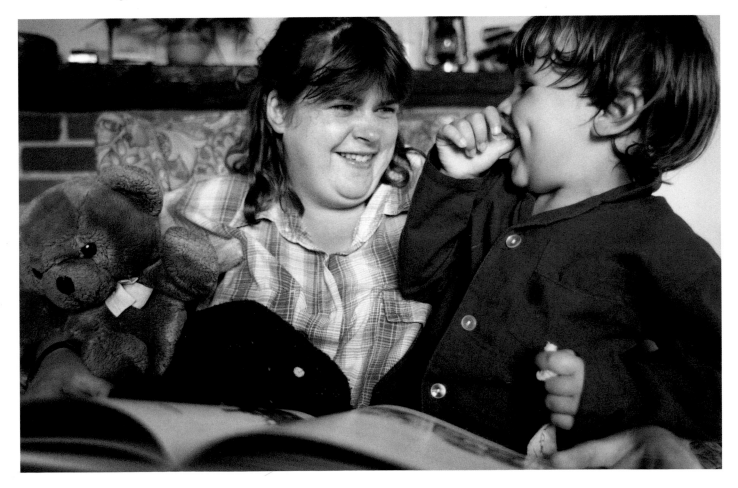

technicalities

Cameras come in all shapes and sizes – and to suit every budget. The type that you choose, however, should depend not only on price and portability, but also on how much control you want over what appears in your photographs.

# cameras

There are two main sorts of camera that you can buy: the point-and-shoot compact or the SLR (single lens reflex). Compacts are usually bought because of their small size and ease of use, but top models can offer you a certain amount of control over your pictures. In particular, the incorporation of more and more powerful zoom lenses into these cameras means you can add more variety to your pictures and take pictures of subjects from a distance. Compacts can use traditional 35mm film, the newer and more versatile APS film, or can record digitally.

SLR cameras usually use 35mm film and have lenses which can be quickly changed to suit the subject. Many now have autofocus, programmed exposure and motorized film winders, so they can be just as easy to use as a compact.

The advantage of the SLR is that it gives you control over the aperture and shutter speed being used. This means you can decide which parts of the picture are in focus. You can also ensure

△ **Zoom compact**

## Choosing a camera...

*Advantages of an SLR*
- Interchangeable lenses.
- Ability to decide which parts of the picture are sharp or not.
- Choice of shutter speed, so you can make the picture sharp or artistically blurred.
- Much easier to use than before, thanks to autofocus, built-in flash, and so on.

*Advantages of a compact*
- Can be very small, making it easy to carry around wherever you go. APS models are smaller than those using 35mm film.
- Point-and-shoot operation.
- Can be bought with built-in non-interchangeable zoom lens, giving a range of focal lengths.
- Discreet to use.

### ◁ Go anywhere

Because compacts are smaller and cheaper than SLRs, you may be more likely to take them with you when you go out. You may be too worried about taking an expensive SLR on a beach, where it may get full of sand. This quickly-shot picture is typical of the type of photograph where the compact excels.

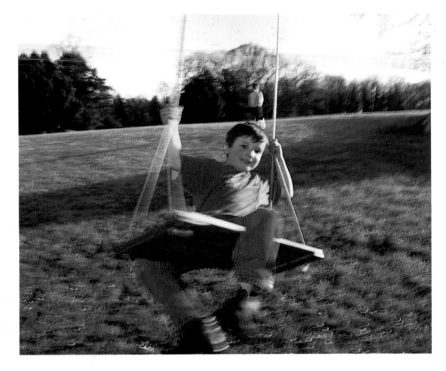

### ◁ Built-in flash

All compact cameras (and some SLRs) have a small built-in flash unit, which will fire automatically in low light. It can also be turned on for use in daylight. 'Fill-in' flash is using for brightening up colours on a dull day, helping to freeze moving subjects, or to counteract backlighting. Fill-in flash is only effective, however, over a few feet.

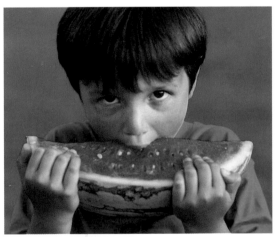

### ◁ Selective focus

Creating a powerful picture often means throwing the background out of focus. The aperture control and through-the-lens viewfinder make this easy on an SLR. With compacts, such control is almost impossible.

## Choosing film...

• It is much easier to get an accurate exposure with colour print film than it is using slides.

• Choose a slow speed film (ISO100 or 200) in bright light, or when using flash. Use ISO 400 for normal pictures. Use ISO 1000 or faster film when shooting in low light without flash.

• For a change, try a black-and-white film.

that you use a shutter speed that ensures that the picture is sharp, even when you or the subject are moving. These settings can be handled automatically for you, but they allow you to be more creative with your photography when you want to be.

### ▷ Everything sharp

Using a small aperture on an SLR, you can make sure that as much of the scene as you want is in focus. Here, this ensures that both the girl and the pram are sharply recorded on the film. Such 'depth of field' control is not usually possible with a compact camera.

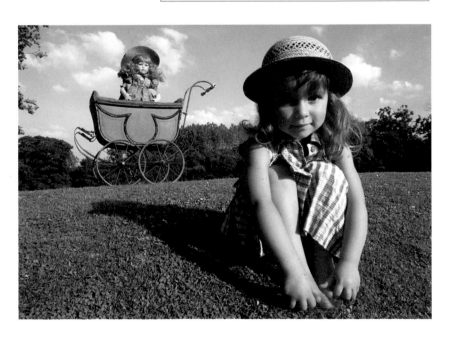

Shutter speed and aperture are the two fundamental controls in creative photography. They not only decide how bright the picture will be, they also decide how sharp the various elements of the shot will appear in the image.

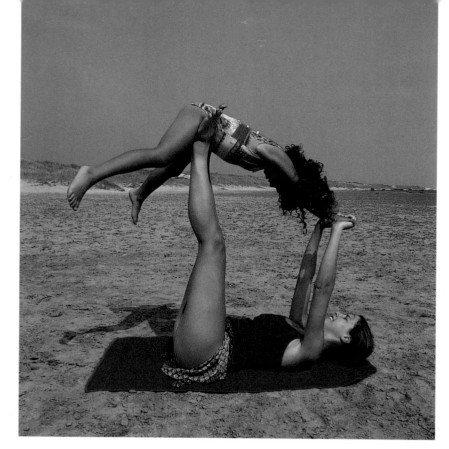

△ **Fast shutter**

The faster the shutter speed you set on the camera, the sharper moving subjects appear on film. The exact shutter speed that you require depends on the speed and direction of movement of the subject and how big it appears in the frame. For this picture I used a shutter setting of $\frac{1}{1000}$sec. The trouble with the fastest shutter speeds is that it might not be obvious from your pictures that the subject was even moving in the first place.

# exposure

Exposure is the amount of light needed to produce a picture on film, and as some scenes are brighter than others, the camera needs some way of compensating for these variations.

All but the most basic cameras use two different ways to control how much light reaches the film: shutter speed and aperture. The aperture is the adjustable hole that opens in the lens; this can be varied in size to let more light in. The shutter speed is essentially the time the aperture remains open.

The exact amount of light needed for a picture will also depend on the film being used: the 'faster' the film, and the higher its ISO rating, the more sensitive it is to light.

As well as controlling the brightness of the picture, the exact shutter speed and aperture used can have other effects on how the picture appears.

The aperture is fundamental for deciding what is in focus. A lens can only focus precisely on one distance at a time, but there is a zone in front of and behind this plane that will look perfectly sharp to the eye; this is known as depth of field. The smaller the aperture, the greater the depth of field. Confusingly, the smaller the aperture, the larger the f/number that describes its size; an f/16 aperture is smaller than one of f/8.

Using a faster shutter speed, where the film is exposed to light for a shorter period, can affect how sharply moving subjects appear on film. It can also be used to compensate for camera shake – the involuntary movement of the user's hands when holding the camera.

## Factors that affect depth of field...

- The longer the lens you use, the less depth of field you will have. Wideangles are more likely to keep everything sharp.

- The closer you are to the subject, the less depth of field.

- The wider the aperture you use, the less depth of field there is. To increase how much is sharp in the picture, use a smaller aperture.

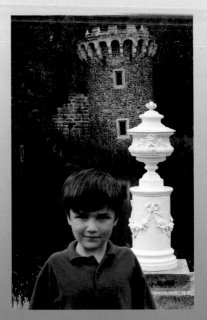

**△ Smallest aperture (f/22)**

With the iris closed as much as possible, everything in shot is sharp.

**△ Widest aperture (f/2.8)**

The background is thrown completely out of focus with an open aperture.

### ▽ Slower shutter

In this shot, the hair of the leaping girl is obviously blurred, as the shutter speed was not fast enough to record it sharply on film. The ¹⁄₁₂₅sec shutter speed is not wrong, however, as the slight blur helps show that the subject is moving.

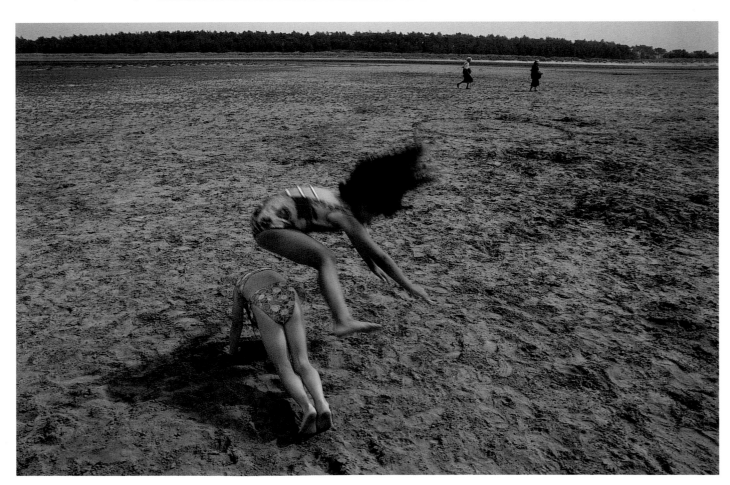

▷ **35mm wideangle**

A 35mm is the focal length of basic single-lens compacts, and is often the widest setting on zoom compacts. Its wide angle of coverage is useful when you want to take portraits that include the surroundings.

Zooms allow you to home in on distant details, or pull back to take in a whole panorama. But the focal length you use will also have other effects on the pictures you take.

# lenses

The focal length of a lens is a measure of its angle of view and just how much it can see of the scene in front of it. Different focal lengths are needed as there are times when you are unable to get close enough, to fill the frame with the subject. The shorter the focal length, the more you can squeeze in. The longer the lens, the smaller the section of scene that is magnified to fill the frame.

The lens range on a compact is limited, as the lens is fixed. On an SLR, a variety of lenses can be bought for every occasion. The economical way of getting a variety of focal lengths for an SLR is to buy one or two zoom lens, ideally covering the 28–200mm range.

◁ **135mm telephoto**

A mid-telephoto lens lets you take close-ups from a reasonable distance, and provides a pleasing perspective to the human face, flattening the features slightly, not exaggerating as wideangle lenses do. A 135mm approaches the telephoto setting you can find on normal zoom compacts, but is well within the range of SLR zooms.

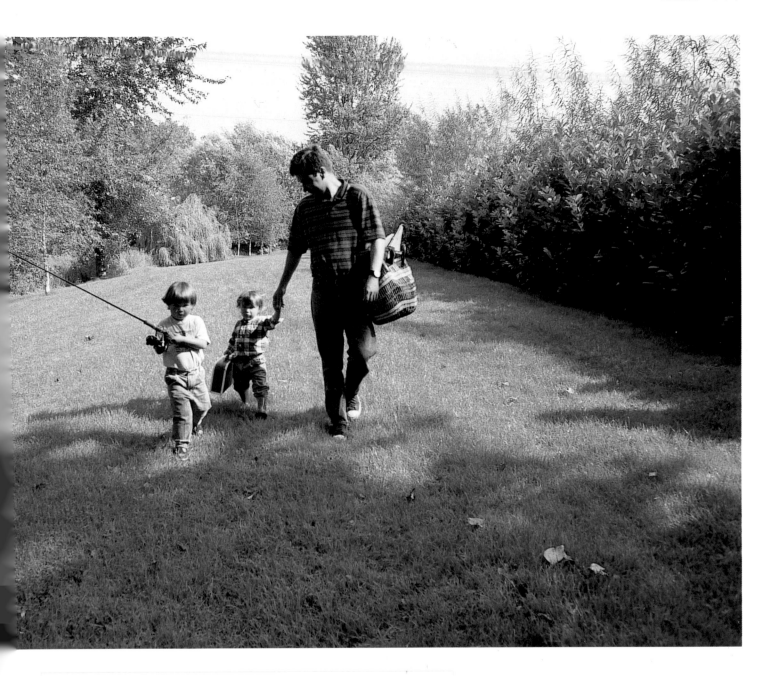

## Different focal lengths for different subjects.......

**Some zoom settings, or lenses, are more suited to some shots than others:**

**28mm or 35mm** – wideangle focal lengths are ideal for when you want to show the surroundings as well as the child. Don't use too close to the subject, or their noses will appear exaggerated in your shots.

**50mm or 70mm** – 'standard' lens settings, offering a halfway house between wideangle coverage and useful telephoto pulling power.

**100mm or 135mm** – the ideal short telephoto setting for portraits, producing the most flattering view of a person's face. Good for head-and-shoulder shots.

**200mm** – good telephoto lens setting for candid shots, where you don't want to intrude too closely on a child and put them off what they were doing.

Focal length not only affects field of view, and depth of field (see p109), it also has an indirect affect on perspective, changing the relative sizes of background and foreground.

Because wideangle lenses are used from closer distances than telephotos, they include more of the background and make it appear more distant. With telephotos, a smaller area of background is shown, and this appears closer to the subject.

Flash is not only useful indoors and after dark; it can be useful in other situations. But it is the quality of light that is as important as the quantity.

# lighting and flash

▷ **Freeze the action**

Flash can be used to capture a moving subject sharply on film. The flash only lights the subject properly for just $\frac{1}{2000}$sec, freezing the action, despite a camera shutter speed of $\frac{1}{60}$sec.

The first and foremost reason for using a flashgun is to provide enough light when shooting in dingy conditions – allowing you to take pictures in total darkness. The trouble with the flash units built into many cameras, however, is that the light source is harsh and direct, often producing an ugly shadow directly behind the subject.

An SLR allows you to add on a flashgun to a 'hot shoe' connector – but this does not improve the quality much, unless it has a 'bounce' head. Bouncing the flash light off a ceiling, wall or slot-in reflector will soften the output, providing a more flattering lighting for the face.

An alternative is to use some form of diffuser on the flash, such as a miniature 'soft box'. The flash also looks better if it can be positioned to the side of the camera, using a bracket.

▷**Bounce flash**

To avoid harsh shadows directly behind your subject, it is worth using a flashgun with a tiltable head on your SLR. This allows you to bounce the light off a light-coloured ceiling or wall, producing a more natural effect, with softer and less noticeable shadows.

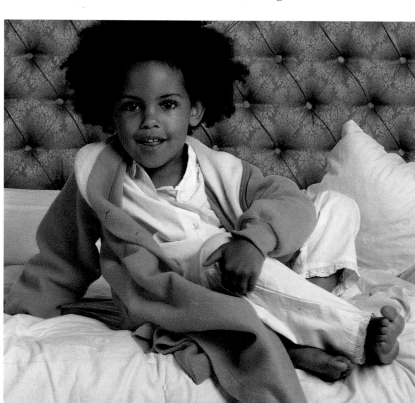

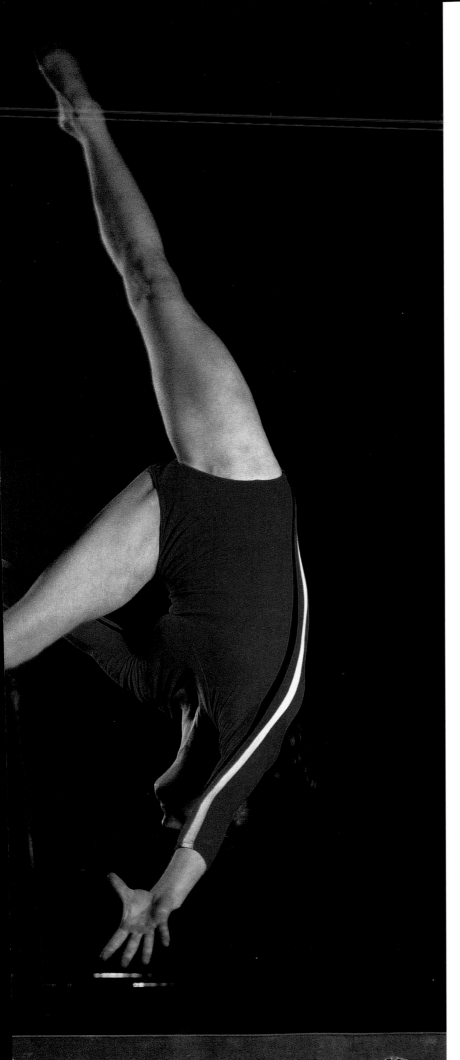

## How to avoid red eyes…

• Flash light can reflect off the retina of the eye, making the pupil appear red in your pictures.

• Avoid the effect by getting closer to your subject, using a less telephoto lens setting as necessary. Turning on all the lights in the room can help.

• With separate flashguns, increase the distance between the lens and the flash tube, using a special off-camera connecting lead.

• Many cameras have 'anti red-eye modes'. The built-in flash is fired several times before the shot is taken, reducing the size of the pupil.

Flash can also be used for helping to freeze action (see pp 38–39), or to reduce facial shadows and improve colours in daylight situations. However, whatever reason you use flash, you must always bear in mind that it is only effective over relatively short distances, even with more powerful flashguns.

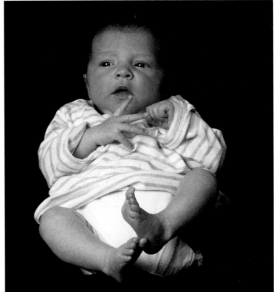

△ **Diffusing the light**

An alternative to bouncing is to use a diffuser over the flashgun. In this shot, I also used the flash to the side of the camera, and then used a reflector on the other side of the baby to soften any remaining shadows.

The home computer has become the modern darkroom, allowing you to improve and alter your pictures with just a few clicks of a mouse.

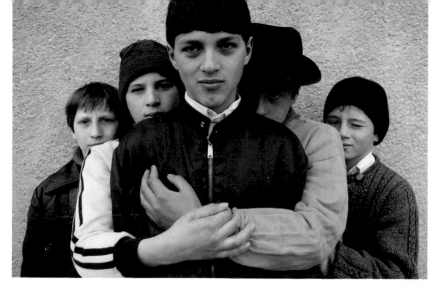

△ **Costume change**
Once digitized, it is a relatively straightforward operation to change the colour of someone's clothes in the shot. Here, I changed the boys' jackets into those of richer hues (original picture on right).

# digital manipulation

Whether you use a digital camera or not, it is very easy to get your photographs into a form where they can be stored and viewed on your computer. Flat-bed scanners are a low-cost accessory for your PC, allowing you to turn your prints into digital computer files. Alternatively, many photo processors offer the facility to transfer pictures onto floppy disk or CD.

Once your images are on your computer, you can do more than look at them – you can transform them using low-cost manipulation software (which often comes packaged with scanners and digital cameras) which allows subtle tweaks or major refurbishment.

Often it is the simpler, less drastic, alterations that prove the most useful.

You can soften and sharpen parts of the picture selectively, for instance, distracting details can be thrown completely out of focus in this way, so that no one will ever know they were there. The eyes of your subject can be made to look that touch whiter, or bluer, with the minimal of effort.

Subtle changes to the colour balance can be made, making the picture look like it was shot at sunset or correcting for blue tone or a winter's day. Changing the colour of a person's clothes is almost as straightforward, whilst completely removing a person from the scene is just a matter of having a good eye for what looks believable, and having the patience to follow the instructions and do things step by step.

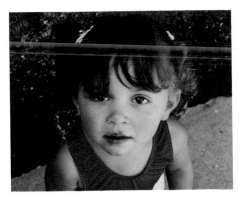

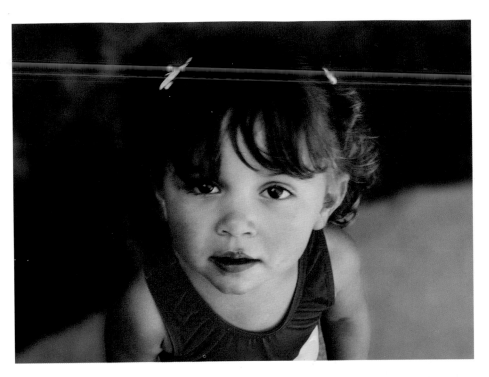

## ▷ Blurring the background

One of the most useful features of digital manipulation software is that it allows you to defocus parts of the picture that you do not want to appear so sharply. Here, the background has been softened so that the girl stands out more than in the original (above).

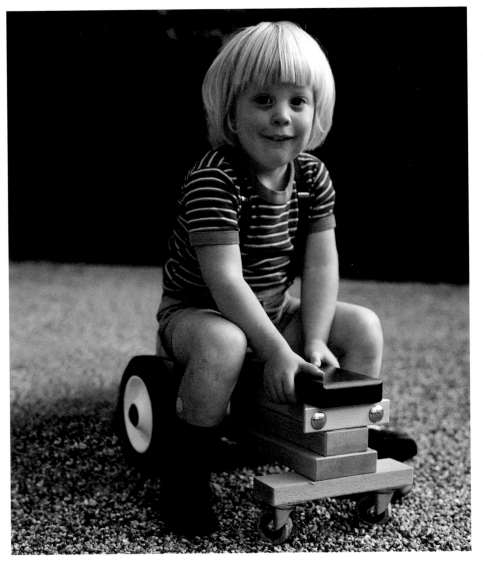

## ◁ Disappearing act

In this manipulated shot, a whole person has been removed so as to simplify the composition. In the original (above) there is a little boy behind the toy train. He was painted out by copying parts of the existing background over the area he took up.

You've got your picture on your computer, you've spruced it up – now what are you going to do with it? Show it to as many people as possible, of course, by sending it by email, putting it on your World Wide Web page, or turning the shot into a greetings card!

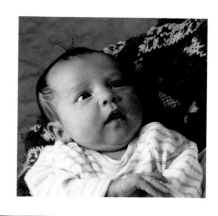

# you've got em@il

△ **Birthday card**

A great way of telling your friends and colleagues about the birth of a new baby is to send them an email with a picture of the new addition to the family. You could even add a soft-edged mask with a digital manipulation package, so that it appears more like a professional picture.

Once you have got your pictures into digital form, you can then not only print off copies of your pictures, you can also send them to people by electronic mail. At very little or no cost, therefore, you can show friends all around the world your children's achievements.

To send a digital picture, you add it to the email as an attached file. The recipient usually doesn't need any special software to read this file – their internet software will be able to open it. Using an email with a picture is a great way of announcing a new addition to the family. To give relatives a more varied selection of pictures to look at, you could set up a home page on the World Wide Web – this effectively becomes an electronic family album that everyone can look at when they want to.

Digital pictures are also a great way to liven up typewritten letters or club newsletters. Many word-processing packages allow you to drop pictures into boxes where you want them on the page. Special paper and card is available to fit into basic inkjet printers, allowing you to run off your own blow-ups, or make your own Christmas cards. Iron-on transfer film is even available, so that your pictures can be put onto T-shirts, making novel presents for grandparents!

### △ Christmas greeting

A posed picture of the children in front of the Christmas tree can form the basis for the family cards the following year. These can be run off on your computer's colour printer, using special photo-quality papers. Using a suitable program, you can add your own message (below).

### △ Family portrait

A shot of the whole family makes a good way to kick off a home page on the World Wide Web. This could give links for news updates, mini biographies and so on. Using a digital manipulation program, you can change the background of your shot (right).

*Merry Christmas*

# index